THE
PHOTOGRAPHIC
ART

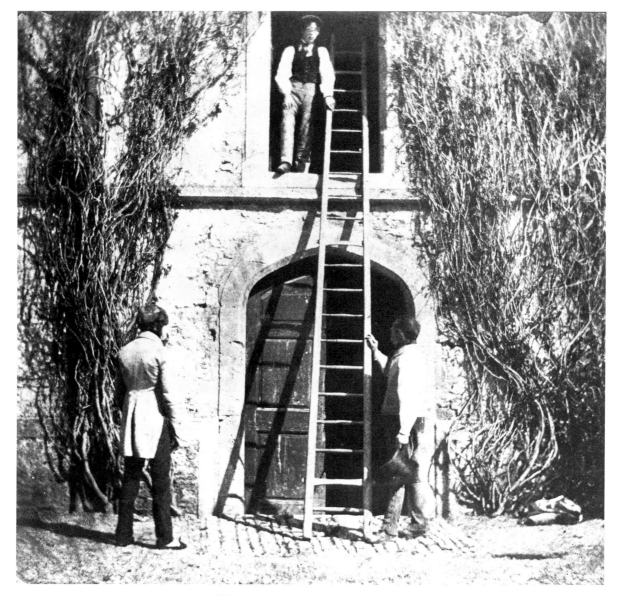

76 W. H. F. Talbot, *The Ladder*, 1844

THE PHOTOGRAPHIC ART

PICTORIAL TRADITIONS IN BRITAIN AND AMERICA

MIKE WEAVER

ICON EDITIONS

HARPER & ROW, PUBLISHERS, New York
Cambridge, Philadelphia, San Francisco, London
Mexico City, São Paulo, Singapore, Sydney

1817

FOR ANNIE

THE PHOTOGRAPHIC ART

FIRST U.S. EDITION

LIBRARY OF CONGRESS CATALOG CARD NUMBER: 85-45898

ISBN: 0–06–430160–5

Designer: Pauline Harrison

Front cover illustration: PAUL CAPONIGRO, *Tecate, New Mexico*, 1979
(no. 63)
Back cover illustration: ROGER FENTON, *Ivory Cup and Fruit*, c. 1860
(no. 61)
Frontispiece: W. H. F. TALBOT, *The Ladder*, 1844 (no. 76)

86 87 88 10 9 8 7 6 5 4 3 2 1

CONTENTS

ACKNOWLEDGEMENTS

This book is based on the exhibition *The Photographic Art* organized by the Scottish Arts Council in 1986.

The Scottish Arts Council would like to express a special debt of gratitude to Dr. Mike Weaver, the selector of the exhibition. Dr. Weaver's characteristic enthusiasm and commitment to photography, evident not only in his selection, is conveyed with equal perspicacity and feeling in the distinguished group of essays published in this book.

Dr. Weaver would like to join us in thanking a number of people who have assisted us in realising the exhibition. Mark Haworth-Booth and Pamela Roberts for their assistance in facilitating the loan of a large number of works from the Victoria and Albert Museum and the Royal Photographic Society respectively; Michael Hoffman and the staff of the Paul Strand Archive and the Silver Mountain Foundation for their assistance in enabling us to include several photographs by Paul Strand in this publication and Professor Peter C. Bunnell of the Minor White Archive, Princeton University.

Finally, we should like to record our thanks to both the public and private lenders, especially those individual photographers in Britain and America, whose generosity has enabled us to tour this exhibition in Scotland.

JAMES BUSTARD
Scottish Arts Council

PREFACE

Though a systematic work has its advantages, yet it is generally attended with this inconvenience, that those who dissent from the system reject it *in toto*: – while with respect to a number of insulated points, each depending upon separate and distinct evidence, a judicious critic will probably be disposed to accept some of them, even if he rejects others. (Talbot, *Hermes*)

A LACK of sensible distinction now exists between the different kinds of photography: scientific, documentary, fashion, advertising, snapshot, and pictorial. This exhibition and book are about pictorial photography, the aim of which is to make a picture in which the sensuous beauty of the fine print is consonant with the moral beauty of the fine image, without particular reference to documentary or design values, and without specific regard to personal or topographical identity. When referring to literature we do not embrace all writing – when we consider photographic art we should not include all photography.

Generally speaking, the classic American tradition in pictorial photography has been committed to truth to facts, although there was a period, 1890–1915, when it turned towards Europe to pursue truth to appearances. The British proclivity to pursue truth to appearances and the American tendency towards truth to facts may be explained culturally, perhaps, by the American desire to map a country, and the British need to un-map one. The British landscape is so domesticated, its Ordnance Survey so complete, that fine effects of weather, time of day, and cultural association are required to satisfy an insular people's need for the broader horizons which were never lacking in the United States. The psychology of national character in art remains an important subject of study, especially in an age of international styles determined by multinational markets.

The American experience of wilderness, be it uncleared forest, open prairie, or empty desert, created a craving for straight information; '*Right* means *straight*; *wrong* means *twisted*.' (R. W. Emerson, *Nature*). It was a moral issue. So fineness in the American sense has meant the delineation of precise detail under a noon sun with clear skies, with the whole scene unmarked by history. This pristine or luminist tendency towards coolness

and clarity in American pictorial photography is complemented by British impressionism which pre-dated the French movement by that name. Both these proclivities, luminist and impressionist, have John Ruskin as their spokesman. His view of art and life could accommodate both J. E. Millais and J. M. W. Turner whom, in his essay on *Pre-Raphaelitism* (1851), he characterised as follows:

> Set them both free in the same field in a mountain valley. One sees everything, small and large, with almost the same clearness . . . Meantime the other has been watching the change of the clouds, and the march of the light along the mountain sides.

It may be useful in this light to consider American photography as possessed of poor memory but with keen sight, and British as richly associative but somewhat myopic.

In the nineteenth century British photography, all kinds considered, was the greatest in the world, but in the twentieth American photography has taken the lead – the history of our two photographies parallels that of our two literatures. In the nineteenth century British photographers were among the best educated members of the middle class, but not until the twentieth century did a comparable group of Americans, the Stieglitz circle, take up photography as a pictorial art. Pictorial photography, like other forms of art, depends for its quality of fineness on the aesthetic and moral education of its practitioners. William Henry Fox Talbot, the British inventor of the paper process, possessed all the attributes necessary to pursue it fully. We tend to think of him as the taxonomist of photography who classified all its possible uses, but he is presented in the Introduction as the first photographic artist. According to his own empirical method, the exhibition and book deal with twenty groups of photographs – insulated but connected – in order to explore their meaning in two cultural contexts.

MIKE WEAVER

A PHOTOGRAPHIC ARTIST
W. H. F. TALBOT

No words are so expressive, none are so rich and powerful,
as those which have *two origins*, and present them to the
mind *in union*. How little has the philosophy of language
yet advanced, when we perceive that this great principle
has been hitherto almost unobserved! (Talbot)[1]

IT HAS BEEN ASSUMED that William Henry Fox Talbot was a scientist who followed systematic experimental procedures of the modern kind, and who pursued empirical operations at all times, when his work in hieroglyphics and etymology suggests that he followed transcendent leads, leapt boundaries and, indeed, backed hunches. Our modern myth of the scientist as a person who works rationally according to an experimental method may apply to parts of Talbot's life but not to all of it. He was in consciousness nearer to Isaac Newton than to us – that same Newton who contributed to modern science but who also wrote more than a million words on alchemy and religion. If Talbot's description of his invention of photography was partly in terms of 'the spells of "natural magic"',[2] his interest in etymology posited some kind of belief in natural language. European emblem art, founded on the rediscovery in the sixteenth century of Horapollo's *Hieroglyphica*, was based on a Neo-Platonism which believed that visual imagery contained occult or hidden truth. The Victorian period saw a great revival of interest in emblems. Sir William Stirling-Maxwell, whose *Annals of the Artists of Spain* was illustrated by calotypes produced at Talbot's Reading Establishment, was the greatest collector of emblem books in the world.[3] *The Talbotype Applied to Hieroglyphics* was another Reading publication which showed Talbot's commitment to the subject.

The most important factor in Talbot's involvement in fine art was his relationship with his uncle, W. T. H. Fox-Strangways, Earl of Ilchester, only some five years his senior. In 1828, 1834, and 1850 Fox-Strangways made a series of donations of early Italian primitive paintings to the Christ Church Picture Gallery and to the Ashmolean Museum, including Uccello's *The Hunt*. The decade prior to Talbot's preoccupation with photography showed him intensely interested in Italian art. His remodelling of the South

Gallery at Lacock Abbey, in 1827, may have been undertaken to accommodate copies of paintings by Correggio, Domenichino, and Raphael, and a painting of the Medusa formerly attributed to Leonardo. Fox-Strangways wrote: 'We shall see a gallery at Lacock & the Cloisters painted in fresco.'[4] By the end of the decade he deferred to Talbot on the latest lithographic processes for copying drawings, and attacked modern engravings as dishonest representations of original works. Talbot's enthusiasm for copying engravings by the photogenic drawing method suggests he was not merely a man of science but someone knowledgeable on the fine arts. He was also deeply conversant with language.

One of the first things one notices about Talbot's *English Etymologies*, published in 1847 immediately after *The Pencil of Nature*, are the repeated references to the sun. Talbot's concept of divine power stems from the sun: *Syncope* and *apoplexy*, in their medical senses of being struck down in a fainting-fit, owe their etymological origin according to Talbot to Sun-coup and Apollo-struck respectively: 'A man struck with sudden death was believed to be killed by the arrows of Apollo. We should call it *Coup de Soleil*, or an *Apoplectic* fit.' No modern linguist dares to risk a reputation on the morphology of the meaning of words any more than modern art historians are willing to do so with images. Talbot himself knew the difficulties: 'Like one who follows Ariadne's clue through a tortuous labyrinth, he may himself be convinced of its safe guidance, but unable to convince others – who have taken a different path.' But he was certainly convinced that *sun* and *gold* were once identical: '*Gyld* or *Gold* meant an Idol in Anglo-Sax.; and what idol so likely as the image of the Sun?' His etymological researches were a kind of alchemical activity with words used as his material. If the force of solar rays was the motive power for his sun pictures his view of the world also had the sun at its metaphorical centre:

> *Orbis* in Latin signifies anything round; it embraces both the ideas of the Sun's disk (and consequently the Sun himself), and that of a *wheel*. It is therefore not impossible that the different etyms of *Yule* may be ultimately found to flow together into one notion of the *Sun wheeling round*.

With such evidence before us (and there are nearly five hundred printed pages of such etymologies to draw upon), Talbot's image as a man of science must be somewhat modified.

Images are treated in Talbot's photography as if they are things, in the same way that he treated words as things:

So very abstract a term as a *thing* must have caused some difficulty to our early ancestors to determine what they should call it. They made choice of a term derived from the verb 'to think'. Any*thing* is any-*think* – whatever it is possible to think of.

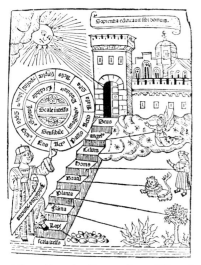

Fig. 1 RAMÓN LULL, from *Liber de ascensu et descensu intellectus*, 1512

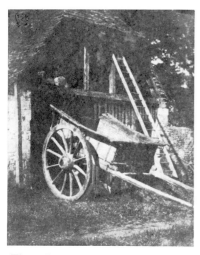

Fig. 2 W. H. F. TALBOT, *Cart and Ladder*, c. 1841 (Science Museum, London)

In the occult tradition words and things are equivalent to each other. The relation between literal and metaphorical language is not analogical but identical, and aquires the power of an actual fact.[5] Photographs partake of the same occult reality. The capacity of photography to record the essence as well as the appearance of things is what has both stopped it from being recognized as art by art historians, and kept it intensely interesting to everyone else. It comprises an aura of the original object rather than being a replica of it, and appears to contain – as traditional kinds of art do not – authentic particles of reality which are more actual than representative. This ultimate nature of photography (its ontological aspect) underpins its accompanying ideas (its rhetorical aspect). Photographs are, therefore, as much indices as icons. They physically present the signified as well as symbolically represent the signifier. They are identifiers and signifiers, appealing both to our sense of fact and of appearance, at the same time.

As signifiers, however, photographs take their place in the memory-systems of Western Europe. The ideas they contain are impregnated with an art of memory which preceded but continued after the invention of printing. The human psyche depends on both natural and artificial memory for its stability. Some people have a natural memory of such a high order of recall that it is described as 'photographic', but artificial memory is what most of us rely upon to improve our knowledge. The traditional classical technique to aid natural memory by artificial means was to place statues or images in rooms of a building which represented the memory.[6] The terra-cotta statues by Sederbach in the Ivory Talbot Hall at Lacock Abbey may constitute such an elaborate system, involving mysteries, doctrines, and beliefs. In the work of Ramón Lull, the fourteenth-century Spanish occult philosopher, the memory-ladder of creation was combined with a memory-wheel (fig. 1); and the combination of a wheel and ladder is found in photographs by Talbot (fig. 2). The four-wheeled chariot of Ezekiel's vision may lie behind Talbot's own photograph of a four-wheeled carriage and ladder.[7] The unity of the world was proposed in terms of Ezekiel's chariot, based on a group of four wheels, and the four gospels. In 1828 Talbot had Raphael's *Vision of Ezekiel* copied. In 1839 he published *The Antiquity of the Book of Genesis*, and joined an immense line of Old Testament commentators who

were, traditionally, the best scholars of the day.

The wheel bears a series of very specific associations. In Bosch's famous haywain picture the spiked wheels which mangle the people who struggle to climb the ladder to the earthly heaven are the same ones used in the attempt to martyr St Catherine. These are Catherine wheels of the kind to be seen in Franceschi's *S. Catherine of Alexandria* given by Fox-Strangways to the Ashmolean Museum, for instance. Talbot's use of carts and ladders can be, of course, simply referred to their place in the naturalistic tradition of English water-colour painting. But this is itself derived from Dutch and Italian painting, and it may well be that the Picturesque tradition in British art springs at some level of pictorial memory from the iconography which constitutes the major memory-system of the Christian world. Dürer's *Sojourn of the Holy Family in Egypt* (fig. 3) contains most of the topics or motifs employed in Picturesque painting: doorways, wells, bridges, staircases – and ladders. That the ladder in Talbot's *The Haystack* serves more than one purpose is not in doubt, but climbing the rick to use the hay-knife is, on this occasion, not one of them. The ladder in Dürer's *Melencolia* is (*pace* Panofsky) not there because building works are in progress but because it takes its place with a wide-ranging set of measuring instruments, and because it suggests a Jacob's ladder extended heavenward above the building. It is a scale of ascent and descent. In the context of a haystack it may represent the only means by which man can resist his fate – 'all flesh is hay'.

Talbot's interest in mythology shows he was learned in the ways of ancient memory in a way that we are not. His antiquarian research on the Medusa suggests he was as committed to the speculative discovery of links between Greek and Etruscan myths as we might be to the iconography of Sacred and Picturesque art. The copy of the Medusa attributed in his day to Leonardo, and the plaster-cast vase with a Medusa-head which he photographed, attest to his serious interest in the Gorgon myth. He explained how the Greeks softened the features, got rid of the monstrous aspect, and kept just the snake in the hair:

> This is an example of the gradual progress of taste effacing the rude symbols of the early mythology, and at the same time making the meaning of the fables more difficult to penetrate, by obliterating the most characteristic parts of them.[8]

He understood the problems of tracing the etymology of myth, but his view was that art always gained and mythology always lost by morphology.

Fig. 3 ALBRECHT DÜRER, *Sojourn of the Holy Family in Egypt, c.* 1502

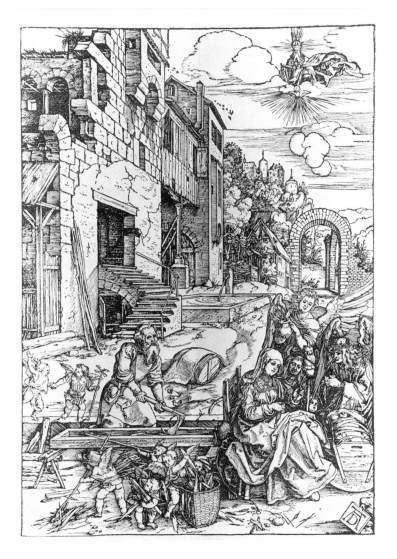

Talbot expressed marked interest in words which come from two disparate sources, and in which the final meaning partakes of both: *hardy*, for example, which he considered came from *heart* and *hard* at the same time. Such words had,

TWO *distinct origins*, which they have coalesced together in course of time, because they represented ideas capable of union. There are many such in modern languages, and they are a most useful and valuable class of words. No wonder, since they contain in themselves, and express with a nervous brevity, the essence of more than one primitive idea.

His etymological studies may be a sign of his commitment to more than one scientific tradition, and indicate that two kinds of knowledge were capable of union in his one mind. If so, his wheels and ladders may coalesce meanings drawn from Catherine wheels and memory wheels on the one hand, and the ladder of the Deposition as in Dürer (fig. 3) and the Lullian ladder of creation or perfection (fig. 1) on the other. The essence of more than one primitive idea need not be lost on us unless we believe that the meanings of Talbot's ladder and cart pictures are intractable except in terms of a degraded Picturesque use of rustic vignettes.

In the Georgian Gothic hall at Lacock is a statuette of Diogenes with his lantern. Of all the statuettes in that hall Talbot chose to photograph this as one of four images made 29 September 1840 by the latent-image process that he called the Calotype. Diogenes, the Cynic, sought an honest man at midday with the aid of a lantern. Talbot's lamp was etymology: 'The etymologist is like a man exploring a dark cavern with the aid of a farthing rushlight; he sees well enough what is near, but there always remains an unfathomable depth of darkness beyond.'

The idea of the unfathomable is beautifully expressed in Talbot's garden picture of his wife and daughters (fig. 4). Three of them regard the little rusticated doorway with the utmost concentration, the youngest daughter facing away from the door as befits her tenderer age. Their heads concealed by their bonnets to make this a typical rather than personal scene, they, too, confront a depth of darkness beyond. The type for such a picture, Talbot's masterpiece, is Richard Bentley's illustration to Gray's *Elegy* (fig. 5). What lies beyond is in fact the grave. The garden tools, the axe, the basket, are found in Turner, and in other pictures by Talbot. But the force of this picture is in the fact that Talbot conceals what Bentley reveals:

> The boasts of heraldry, the pomp of power,
> And all that wealth e'er gave,
> Awaits alike th' inevitable hour.
> The paths of glory lead but to the grave.

It was true for Talbot on 19 April 1842, as it is true for us today.

All the chapter headings of this book – indeed, its very title – are adapted from Talbot's writings, and his *English Etymologies* are quoted throughout the text to provide comment and to draw attention to what has been hitherto overlooked – that the British inventor of photography was a man who fully understood the power of metaphorical thought. Without this the creation and appreciation of pictorial photography are not possible.

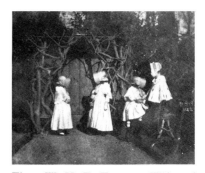

Fig. 4 W. H. F. TALBOT, *Wife and Children*, 19 April 1842 (Science Museum, London)

Fig. 5 RICHARD BENTLEY, Gray's *Elegy*, London 1753

I. A ROYAL ROAD

> It has often been said, and has grown into a proverb, that
> there is no royal road to learning of any kind. But the
> proverb is fallacious: for there is, assuredly, a royal road
> to Drawing. (Talbot)[9]

THE ABILITY to put together a network of drawn lines is no
guarantee of creativity. It is the work-ethic that places a value
on the painstaking care of the draughtsman. This was clearer
in the pre-photographic days of engraving: 'The more complex
and artificial the technique of a print, especially in the way its lines are laid,
the more certain one may be that its maker was a craftsman translator and
not a creative artist' (William M. Ivins).[10] But photography is not about
laying lines, either drawing (pulling) them or engraving (pushing) them. It
was Sir David Brewster who said, wisely, that photography was more than
engraving but less than painting.[11] Logically, of all kinds of engraving it
was the mezzotint which appealed most to British taste because it imitated
the masses of painting rather than the lines of drawing. It was not the revolu-
tion of 1848 which determined the invention of photography but the produc-
tion of Turner's *Liber Studiorum*, and David Lucas's collaboration with
Constable on *English Landscape Scenery* (1830–31). Talbot, like Ruskin, was
taken with 'an invention which delineates in a few moments the almost end-
less details of Gothic architecture which a whole day would hardly suffice
to draw correctly in the ordinary manner.' But, like Brewster, he also realized
that the tonal effect of photography, which gave it 'its peculiar touch',[12] was
inimitable, except in painting – or rather watercolour. The British loved
the tonal effect of mezzotint for its soft edges. They liked aquatint for its
soft, flat tones, and well defined edges. Both processes are characteristics
of the British tradition in ink and wash drawing which became watercolour
drawing. The Americans, for practical and psychological reasons, wanted
information. The straight aesthetic in American photography, based on per-
fect execution and high finish, stems from a Ruskinian obsession with detail
and an industrial enthusiasm for high technology. It can become very *prim*,
neat and finicky at the same time. Talbot contrasted it with *fine*: 'The adjec-
tive Fine means thin and delicate, it also means graceful or elegant.' Such
a distinction provides a useful analogue for the painstaking care and freedom

to create implicit in the words design and drawing. Unfortunately, design has come to mean a way of stylishly organizing material to produce a pleasing appearance in a prim, Modernist manner.

What is remarkable about Pradip Malde's *Ideal Mathematician* (1) is that it combines two factors which refute glib notions of design. The softness of the palladio-platinum print rejects high finish as the goal. The appearance of the image is idealized in the sense that it seems to reflect an idea of the world as lines drawn upon white space when, in fact, it is a close piece of natural observation. Some of the 'lines' are the lines of wire of the actual fence, some are shadows of those lines. Something similar occurs in Harry Callahan's reeds (2) where the reflections of the reeds are so coterminous with the actual reeds that we cannot tell the reflection from the reality. The lines of the reeds are mediated by water as Malde's wires are mediated by snow. In Aaron Siskind's seaweed picture (3) the 'ground' is sand. Only, the raised line of the seaweed is in relief while the footprint is in intaglio. Nature has made a plate in two processes which are essentially incompatible, yet the footprint and the seaweed are imaginatively related as indicative of man's riparian origin. The photographic surface unites them. A tilted camera achieves all this, an angle of vision introduced into Anglo-American photography at the turn of the century from *Japonisme*. Whistler absorbed it early, and Arthur Wesley Dow, a great American art-teacher, introduced it to the Alfred Stieglitz circle through Alvin Langdon Coburn and Clarence White.[13] In Japanese composition the elements of the picture plane are piled one upon the other vertically, instead of being induced to recede in depth according to Western perspective. In George Davison's *Harlech Castle* (4) the least obtrusive element is the dark castle itself, tucked away on the left. The composition features the marram grass much more strongly. It was not the only time Davison reversed our topographic sense of priorities. His best known picture, *The Onion Field* was once called 'The Old Farmstead' but nevertheless featured the onions. On this basis, the Harlech Castle picture should, perhaps, really be called 'The Dunes'. What is happening is that topographic interest is being depressed, and an apparently more transient element, coarse grass in sand, being stressed. Coburn did something similar in his great picture of St Paul's cathedral with a cloud of train-smoke. The picture is usually titled *St Paul's* but it could well be called 'The Cloud'. The ephemeral aspects of the landscape are brought, literally, into alignment with monumental elements. Reflection in Davison and Coburn can be a quality of meditation in relation to the temporal order. It goes beyond the physical subtleties of Callahan and Siskind. It engenders feelings. P. H. Emerson's

famous *Rushy Shore* retains the buildings of the Anglo-Dutch tradition of river painting which Callahan, a formalist, presumably never missed. Raymond Moore's snowscape (5) also keeps a firm contact with reality despite his Modernist composition. We know that the image is made up of flat ground and a hillside, but it does not feel like that. The telegraph pole dead-centre, its wires running left and right without visible means of support, is an anti-recessive device so strong in its effect that the sheep-line and the cable are in the same plane. Some of the sheep are strung out on the cable. So sheep and human communication are physically and mentally related. The pastoral tradition is remade at the end of the twentieth century, not sentimentally but according to Moore's own tough but compassionate standard. The two trees half-buried left and right at the edge of the frame relate to the telegraph pole which, having no roots, must rely upon a single stay.

1 PRADIP MALDE,
The Ideal Mathematician, 1984

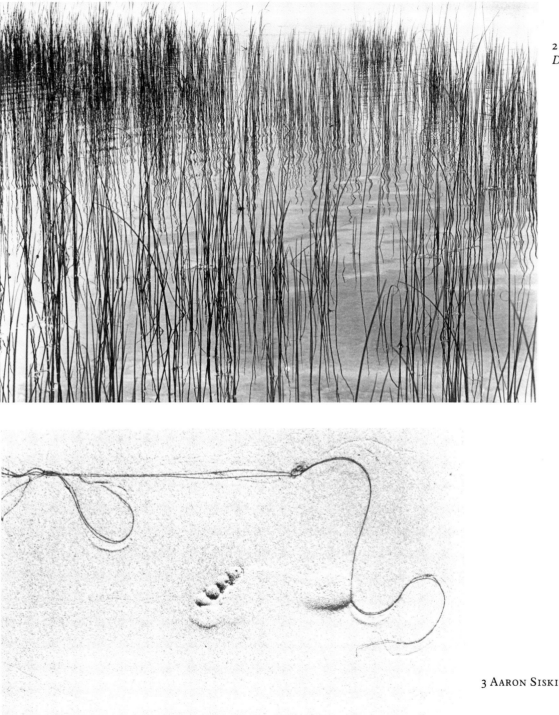

2 HARRY CALLAHAN,
Detroit, 1941

3 AARON SISKIND, *Seaweed 4*, 1952

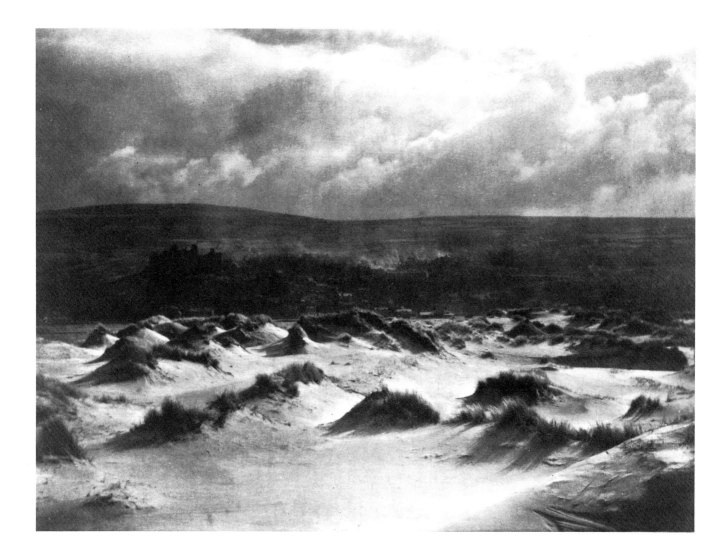

4 GEORGE DAVISON, *Harlech Castle*, 1903

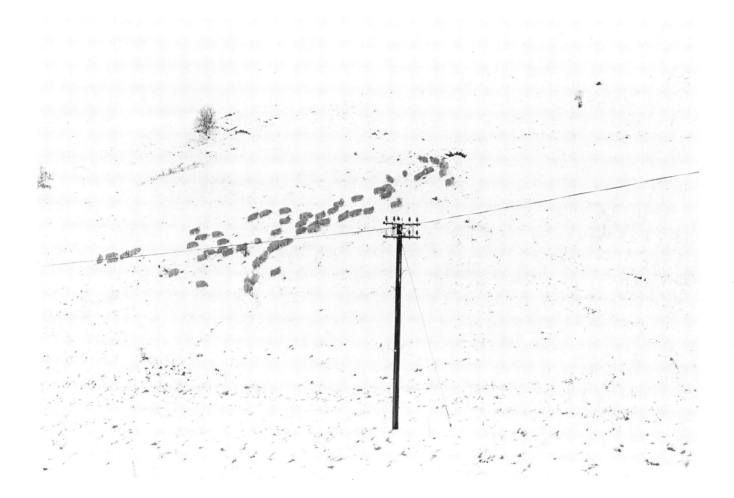

5 RAYMOND MOORE, *Raes Knowes*, 1980

2. A MULTITUDE OF MINUTE DETAILS

I have got to such a pitch of fastidiousness that no drawing
will satisfy me at all as regards its expression of mere facts
– but I must have a daguerreotype or a cast – and even
grumble at those, at the one for exaggerating the shadows
– at the other for losing the sharpness of the hollows.

(Ruskin)[14]

BY 1853 RUSKIN was an expert daguerreotypist, and had probably experimented with the wet collodion process as well. It is interesting that he preferred the French system, which became the dominant American process, to the British system invented by Talbot and used by Hill and Adamson, although he was acquainted with the calotype. He seems to have appreciated the daguerreotype's power to render architectural detail at a time when the conservation of the buildings of Venice was uppermost in his mind. The soft chiaroscuro of the calotype was less useful to him than the sharp literalness of the mirror process. The calotype was, like the mezzotint, mostly tonal and Ruskin did not like the loss of line. However, the mezzotints of Turner's *Liber Studiorum* show evidence of having been etched for line before the surface was rocked and scraped for tone, and other accents were obtained by pointing up by engraving.

Ivins made a distinction between German and Italian engraving which may be useful in comparing American with British photography.[15] The early Germans were really goldsmith-engravers making linear miniatures, whereas the Italians were painters who made decorative prints with flat spaces and larger volumes. The German woodcuts and engravings have to be examined close to the surface of the print, whereas the Italian ones are to be seen at a distance. Ruskin's obsession with detail conflicted with his demand for pictorial imagination. His Pre-Raphaelitism emphasized detail but his love of Turner contradicted it. His influence in America dates from 1855 when one of his draughtsmen, William J. Stillman, became an editor of *The Crayon*. Art in America, like all ex-colonial art, was out of step with Europe by about fifteen years, so the Pre-Raphaelitism of the first, highly finished phase of the forties remained current there almost until the eighties when Naturalism and Impressionism permeated the New English Art Club where P. H. Emerson found his friends.

One hundred years after Pre-Raphaelitism Ansel Adams' bank of vegetation (6) was made on Ruskinian principles: 'The higher the mind, it may be taken as a universal rule, the less it will scorn that which appears to be small or unimportant; and the rank of a painter may always be determined by observing how he uses, and with what respect he views the minutiae of nature . . . he who cannot make a bank sublime will make a mountain ridiculous.'[16] But Adams' picture is a *detail* of a bank. Focused a mere six inches from the nearest leaves, it is a gem photographed with a Zeiss Juwel camera. Such a close-up reveals swords of grasses and shields of leaves guarding tiny flowers. 'A certain kind of leaf is called by botanists folium *gladiatum*, or *ensiforme*, from its resemblance to the blade of a sword' (Talbot).

Paul Strand was especially interested in the iris as an example of the gladiator's sword, but his view of nature is altogether more emblematic than Adams'. His buttercup leaf is set against a cobweb (7), hidden at whose centre sits a creature which has fired fine threads to make a network in which to catch not flies, it seems, but raindrops. The geometry of the web is encrusted with them. Strand wrote in the preface to *Time in New England* (1950), in which this image appeared, that he found in modern New England images of nature that were related in feeling to its great Revolutionary tradition. So how, then, does this image fit in with that? The answer is in the buttercup leaf, which Ruskin drew so lovingly to illustrate his writing about the plant.

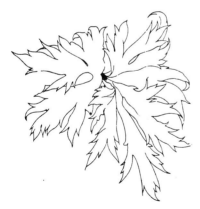

He noted that the endlessly expressive forms of the plant 'are such as will not be visibly injured by crushing. Their complexity is already disordered: jags and rents are their jaws of being; rent by the footstep, they betray no harm.'[17] The plant's beauty lay in its variety and its freedom of growth but above all in its uncrushability. It would seem that Ruskin saw the buttercup leaf as a type or emblem of the downtrodden but undashed, and that Strand

compared this quality with that of the geometrical cobweb with its crystalline finery. It would be going too far to say that Strand saw his image in tems of socio-economic struggle, but the handling of image and text in *Time in New England*, and his film *Native Land* (1938–42),[18] both suggest that he was a social typologist in method. Adams subscribed to Ruskin's idea of vital beauty: the mountains of the earth were natural cathedrals to him. Strand, who may have inherited the socialist programme of Ruskin through his teacher Lewis Hine, followed, perhaps, Ruskin's idea of typical beauty transposed from Christian to Marxist terms. The archetype was more important than the individual.

White's picture (8) also depends as much on ideas as on material facts. This time the network is man-made, only it, too, catches rain water very beautifully. The large glass ball set before the screen embodies the Blakeian idea of the world in – a droplet of water. But the child in the picture adds a new dimension. The child moves the image beyond the natural to include the human. The globe is, perhaps, a crystal ball in which the future of the child might be seen – a giant tear-drop sympathetic with the raindrops on the screen. The feeling of the picture is one of reverent sadness, because the overtone of the theme, *homo bulla*, the boy with the bubble, is present also. It is a *vanitas* emblem for all its perfect roundness:

> The little boys, that strive with all their might
> To catch the bells, or bubbles as they fall:
> In vain they seek, for why, they vanish right.
> Yet still they strive, and are deluded all.[19]

6 ANSEL ADAMS, *Trailside, Alaska,* 1947

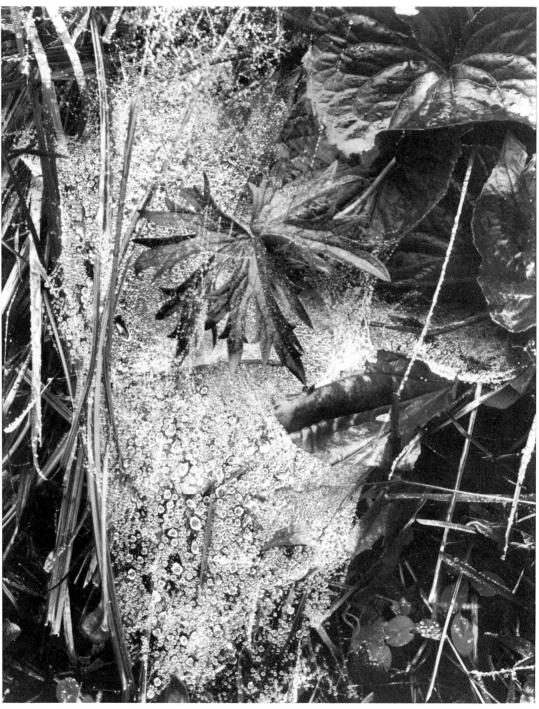

7 PAUL STRAND, *Cobweb in Rain, Georgetown, Maine,* 1927

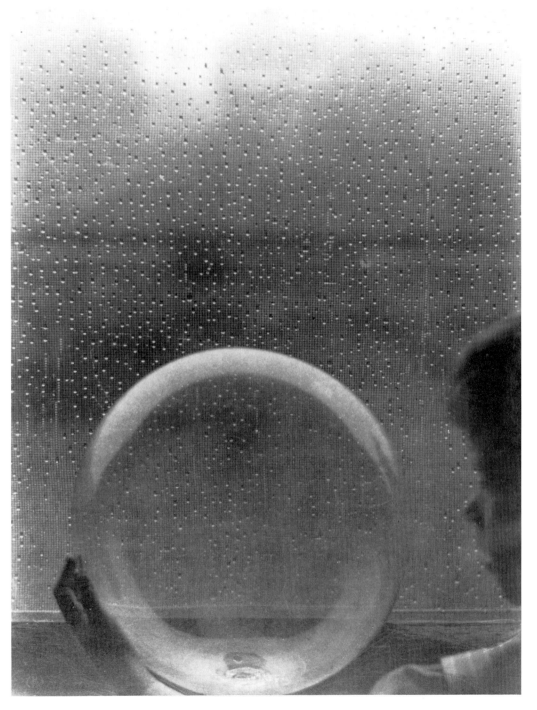

8 CLARENCE H. WHITE, *Drops of Rain*, 1903

3. FAIRY PICTURES

Any work of art which represents, not a material object, but the mental conception of a material object, is, in the primary sense of the word, ideal. That is to say, it represents an idea and not a thing. (Ruskin)[20]

WHEN TALBOT said 'fairy pictures' he meant his magical sun drawings. When David Octavius Hill called a tree in Colinton wood a 'fairy tree' he was probably thinking of a painting by his brother-in-law, Sir Joseph Noel Paton, of *A Midsummer Night's Dream*. Pictures may be both enchanting and enchanted. Talbot's trees and bridge (9) are magical in the sense that the elements are put before us in such a way as to rouse our imaginations according to certain ideas of beauty. The tree in the centre droops somewhat sadly over the bridge. Two trees to the left compete mutually for space. The dead stump to the right reminds us not only of natural decay but the possibility of being blasted. The rusticated bridge shows how a new order of beauty can be wrested from trees sawn down and boughs bent into new shapes. But the bridge and wall need moss, and ivy, and lichen to receive the touch of nature again, in order to join the tradition of the picturesque, derived from Dutch and Italian painting. The broken stump, for instance, is found in Salvator Rosa. Another picturesque motif is the wicker fence and tree. Its origin is in the mediaeval paintings of the Virgin in the garden, the *hortus conclusus*. It is found in the work of Dürer, for instance, where the primary mediaeval form is already beginning to be naturalized, but the derivatives of the motif in the British watercolour tradition can still be detected in Hill and Adamson's tree and fence (10). The visual etymology of the British picturesque has still to be written, but when this is done our tradition of landscape and genre photography will be seen to have some deeply traditional continuities. The whole notion of the Picturesque is founded on knowledge of pictures, and Hill was well schooled. Richard Payne Knight developed an idea of perception improved by the knowledge of pictures in *An Analytical Inquiry into the Principles of Taste*:

This very relation to painting, expressed by the word *picturesque*, is that, which affords the whole pleasure derived from association; which can, therefore, only

be felt by persons who have correspondent ideas to associate; that is, by persons in a certain degree conversant with that art. Such persons being in the habit of viewing and receiving pleasure from fine pictures, will naturally feel pleasure in viewing those objects in nature, which have called forth those powers of imitation and embellishment . . .[21]

Common sense tells us that the impression Hill and Adamson's picture makes on us is antiquarian (an old photograph) and purely sensory (a fence and tree). But the man who designed and arranged the shot also followed principles of association as well, which strengthened his sensory impression, and induced feeling. Talbot was deeply sensitive to the recovery of meaning in words, so why should he not have been sympathetic to the retrieval of meaning in pictures? He knew the difficulties, but, like Diogenes, he never gave up searching.

Thomas Joshua Cooper, almost a century and a half later, initially made his marvellous pictures six thousand miles away in California. Now he makes them here in Britain but still according to his own sense of very ancient, primitive, and universal terms. As an American his search for origins, his understanding of migrations and settlements, follows a comparative religious approach. Perhaps he knows Cid Corman's magazine *Origin* with its Oriental emphasis, or Charles Olson's anthropological essays, or has studied Jung's idea of the collective unconscious. These are some of the modern sources for the continuance of a great tradition of religious and moral thought stemming from Ralph Waldo Emerson and William James. But he certainly knows his Morris Graves, and his Theodore Roethke:

> In a dark time, the eye begins to see,
> I meet my shadow in the deepening shade.[22]

The constancy of physical ambiguity, the tendency of the mind to perceive one thing as another, is the way Cooper handles his close-ups of nature, which are in British nineteenth-century terms, 'picturesque bits'. The taste for such subjects is even older, as Francis Hutcheson suggested early in the eighteenth century:

The *Beauty* of *Trees*, their *cool Shades*, and their *Aptness* to conceal from Observation, have made *Groves* and *Woods* the usual Retreat to those who love *Solitude*, especially to the *Religious*, the *Pensive*, the *Melancholy*, and the *Amorous*. And do we not find that we have so join'd the Ideas of these Dispositions of Mind with these external objects, that they always recur to us along

with them? The Cunning of the *Heathen Priests* might make such obscure Places the Scenes of the fictitious Appearance of their *Deitys*; and hence we join something *Divine* to them.[23]

Cooper's message to Narcissus is a warning to himself (11). In what looks like a pool of water (on closer examination a rock-face) the shadows are so distorted by the high angle of the light source as to make of them a reality as substantial as the trees which produce them. Talbot wrote, 'The most transitory of things, a shadow, the proverbial emblem of all that is fleeting and momentary, may be fettered by the spells of our "natural magic".'[24] Once fixed these creations of a moment become reflections of the soul.

9 W. H. F. TALBOT, *Trees and Bridge, c.* 1844

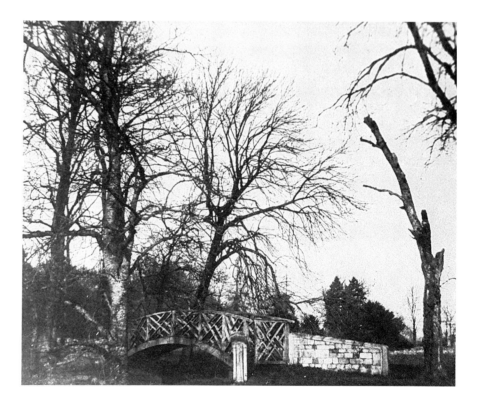

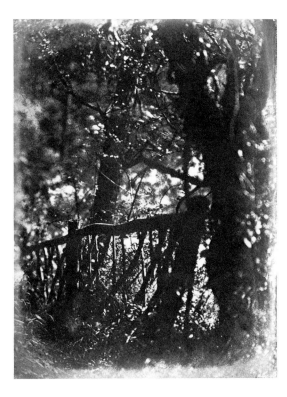

10 D. O. Hill and Robert Adamson,
Colinton Wood, c. 1845

11 Thomas Joshua Cooper, *Ritual Guardians (Message to Narcissus), Nesscliffe, Shropshire,* 1975

4. HISTORICAL RECOLLECTIONS

What is it that gives us Pleasure in Reading a History, or
Poem, but that the Mind is thereby furnish'd with Variety
of Images? (Jonathan Richardson)[25]

WHAT WAS IT, to the Victorian mind, that gave it such pleasure in looking at pictures, but that it was enriched with an overlay of literary meaning? The Victorian knowledge of the Bible, not to speak of Milton and Shakespeare, made of them all connoisseurs by our modern standard. The taste for landscapes of historical and literary significance was an expression of the theory of the association of ideas adopted by writers on the Picturesque. Francis Frith, photographic illustrator of *The Queen's Bible* (1862–3), was a Quaker whose knowledge of the Bible was exceptional even by Victorian standards. Between 1856 and 1859 he made several exploratory voyages up the Nile. At the great river's First Cataract he photographed the island of Philae (12). Another version (fig. 6), which relates better to Frith's accompanying text, includes a characteristic – that is, Picturesque – boat at the landing, but the version without the boat aims higher, in every sense of the word. Despite the tourist description, *Pharaoh's Bed*, the island embodied a cross section of history. Its building contained a temple to Isis by an Egyptian pharaoh, churches of the Egyptian Christians (the Copts), and this Roman kiosk. The incentive to historical recollection was very great. But the Coptic association is most important. Egypt was, after all, an extension of the Bible lands. It was to Egypt that the Holy Family fled to escape Herod until the prophecy, 'Out of Egypt have I called my son', was to be fulfilled. In Renaissance painting the palm tree is a common motif referring to the Flight into Egypt. But Frith's picture can be read at another level. A tourist with a taste for landscape, more used to Gothic ruins accompanied by deciduous trees, or Greek ruins accompanied by conifers, would have found this Romano-Egyptian ruin with palm trees excitingly fresh. The palmyric and the cubic were linked by the resemblance of the palm fronds to the composite capitals of the columns of the kiosk. This was a *new* version of Milton's lines from *L'Allegro*:

Towers and battlements it sees
Embosom'd high in tufted trees.

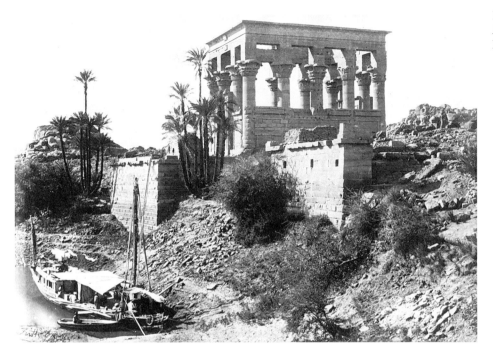

The readers of Humphrey Repton's *Sketches and Hints on Landscape Gardening* (1794) would have known that an addition to the syntactical relations between trees and buildings had been made.

Wright Morris's picture of a smokestack and a palm tree (13) was also made for historical reasons, and his interest in 'the worn and the abandoned' would have held no surprises for a nineteenth-century watercolourist. 'The Depression was spectacularly photogenic ... So many structures (souls) eager and willing to be saved might otherwise be lost! I had watched a barn collapse while I hastened to set up my camera ... I wanted the representative structure that would speak for the numberless variations.'[26] In other words, Morris was in search of types and symbols like Strand in New England. His interest was metaphysical like Walker Evans's, however, rather than political like Strand's. Edward Weston had learned in the twenties that a smooth palm trunk in Mexico could interest him in American factory chimneys. Like the Precisionist painters in the Stieglitz circle Weston was fascinated by the analogies between organic growth and machine-made construction, and Morris got them into the same picture. His picture is as much about differences as resemblances. The elements on the right – palm tree, dwelling, telegraph pole, and range of hills – represent an earlier period than the smoke-stack on the left. The steel rails unify the picture both histori-

cally and visually, and the industrial growth that they represent produced the functional beauty of the powerhouse. The key to the picture is dead centre: white wooden sheaths for the stays and their shadows are set against white shutters. In abstract terms it is related to Van Doesburg's Elementarism – Mondrian with the addition of inclined planes. In Picturesque terms it is related to the pieces of timber which lean against walls in the British watercolour tradition, and in Talbot's work, but here the motif is neither entirely abstract nor entirely figurative. It is detached from the wall and attached to the stay in an incongruous manner (what is the *function* of those pieces of wood?). It is a highly representative structure, however, in that it is a kind of hieroglyphic form of both the palm and the stack. The shadows, in the best Precisionist manner, do not signify time of day, but parallel the angle of inclination of the palm fronds. The white shutters do not so much reflect the light as signify flat smoothness against the shiny roundness of the stack and broken roundness of the palm trunk. The picture may be Precisionist in its immaculate finish, its cool stillness, but its central motif of inclined sheaths carries a meaning quite disproportionate to its apparent importance. It expresses an extraordinarily tensile order: perfectly taut, and perfectly relaxed.

The work of Linnaeus Tripe in India in the eighteen fifties was largely topographical. The surface beauty of his lightly albumenized prints has led recently to an over-estimation of their pictorial value, but up to ten percent of his six-volume set of images made in the regions of the Madras Presidency, for which he was official government photographer, are of such interest. Tripe's palm trees, compared with Frith's and Morris's, are wildly disordered. The little pagoda at Seringham is a mere pretext for a romantic treatment of the trees (14). The fantastic angle of the leaning palm trunk produces the pleasure of surprise and amusement, rather than any kind of historical association. It is good that the Madras Presidency was able to sponsor and accept an image of such curiosity. The wind-swept trees in movement are characteristic of the British tradition in painting, watercolour, and photography. We have never been afraid of wind and weather like the Americans have, until recently, when Callahan and Cooper have welcomed such movement in their images. Americans like Morris, Adams, and Walker Evans prefer a pristine stillness. P. H. Emerson's dictum, 'Aeolus is the breath of life of landscape,' had little effect on them. The American eye has become too prim to accept such broad effects, the American mind too terrified of transience to accept anything but utter silence. Wind is time. To accept it is to accept history.

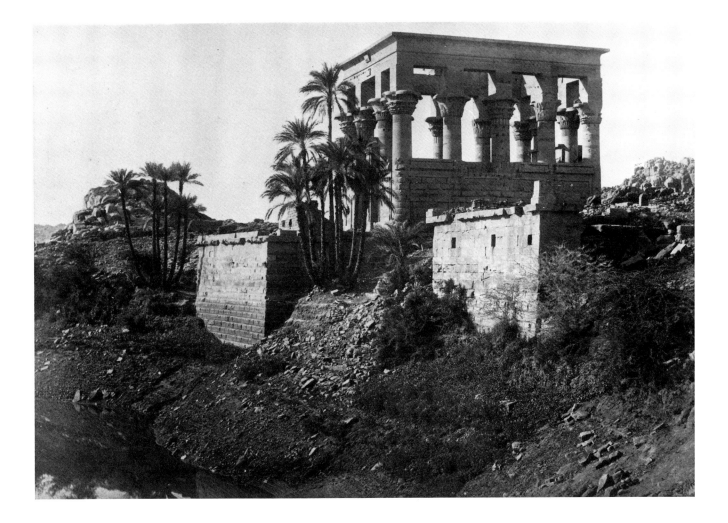

12 FRANCIS FRITH, *The Island of Philae*, 1857

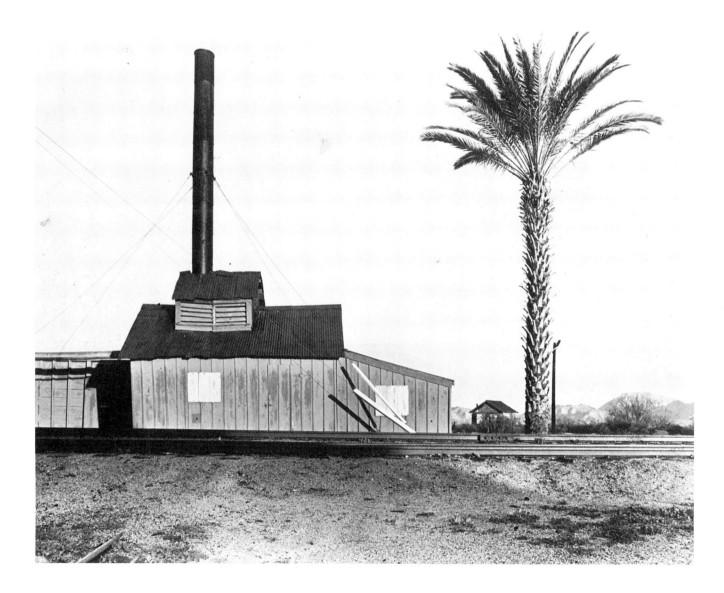

13 WRIGHT MORRIS, *Powerhouse and Palm Tree, near Lordsburg, New Mexico*, 1940

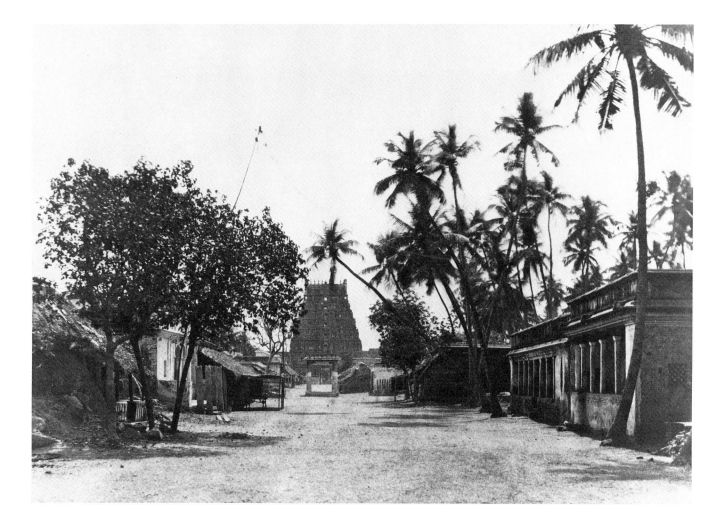

14 LINNAEUS TRIPE, *Little Pagoda, Seringham, 1858*

5. SOUVENIRS OF THE SCENE

Anything more beautiful than the photographs of the
Valley of Chamouni, now in the print-sellers' windows,
cannot be conceived. For geographical and geological
purposes, they are worth anything; for art purposes,
worth – a good deal less than zero. (Ruskin)[27]

TO OFFER MORE than topography the photographer must so stimulate the viewer with the facts of the scene that some kind of participation or identification takes place in the mind. Ideas must be evinced in one way or another. Pure information is not enough. Ruskin argued in favour of such information as well as against it: 'Pure history and pure topography are most precious things; in many cases more useful to the human race than imaginative work; and assuredly it is intended that a large majority of all who are employed in art should never aim at anything higher.'[28] But he also believed that Turner had achieved a mental rather than optical vision of landscape. From the British point of view the work of Timothy O'Sullivan and Carleton Watkins remains geographical rather than expressive. If there is any poetry it is of very muted kind.

Watkins used a frame of trees to enclose his picture (15), and a double focus of interest to relate near to far in his perspective. In his Columbia River pictures he often used a sawn-off tree stump in the foreground to rhyme with the main subject of the picture. The incongruous thought may strike us that the tree has been sawn off in order to make the view, but this was, in fact, a device by which he unified his picture. The feelings it induces are disturbing. Walker Evans' broken stump stands in front of a ruined Southern plantation house and creates a similar feeling of pathos. At one level such stumps symbolize the great clearing of the land which the exploration of the West implied, and which Adams, surely, found tragic. When Adams used such a compositional device, employing boulders to rhyme with Mount Williamson, he did so to fulfil Ruskin's dictum that stones were only mountains in miniature. When Watkins did it the effect was to show that the great garden was blighted, and that American society was already post-Edenic. The silence, stillness, absence of human activity in Watkins and Adams is characteristic of American landscape photography in a way not

characteristic of British. Thomas Cole, an English immigrant, and Frederick Church, his pupil, retained the British approach to the sublime in nature with its evidence of weather. They remained atmospheric painters. But two traditions of the sublime, one apparently objective and another subjective, developed side by side. In Church's great painting of the Niagara Falls in the National Gallery of Scotland the foreground is Pre-Raphaelite and contemplative, and the background Turnerian and sublime. Thomas Moran, another English immigrant, who was still alive for Coburn to meet him in Los Angeles in 1911, painted the Grand Canyon in a realistic manner and made etchings in a Whistlerian, impressionist manner. Adams's Snake River (16) compared with Minor White's (17) shows that within the American tradition two different sublimes co-existed, the contemplative sublime (Adams) and the atmospheric sublime (White). White was not afraid of movement. Adams insisted on absolute stillness. The difference between the two great men was essentially philosophical. Adams was an inter-state photographer – he covered the grand distances in the manner of a certain kind of painting called luminist.[29] It is counter to impressionism in tendency:

LUMINIST		IMPRESSIONIST	
cool	restful	warm	agitated
hard-edged	potential	soft-edged	realized
transparent	conceptual	opaque	natural
glossy	literal	matte	visionary
tactile	anonymous	elusive	egocentric
still	classical	moving	romantic
soundless	Emersonian	sounding	Coleridgean

Adams's image is a comprehensive piece of geography making the most of deep perspective and fine tonal gradation. Like Fenton's picture (18) it makes full use of the serpentine form to lead into the grand scene. The river winds placidly through vegetation with soft, rounded banks at the last corner before it glistens through more trees. It follows Hogarth's 'line of grace': 'And that the serpentine line, by its waving and winding at the same time different ways, leads the eye in a pleasing manner along the continuity of its variety, if I may be allowed the expression; and which by its twisting so many different ways, may be said to enclose, tho' but a single line, varied contents.'[30] How well this works for Roger Fenton, as we are taken past logs, fence, more timber, a little narrative of a man and two women at a gate, past two men chatting, to a child with a man, and so on in imagination to the cottages

39

beyond. Note, incidentally, that pile of timber partly leaning against the side of the hill and partly against trees, and compare this motif (because this is what it is) in relation to the white wooden sheaths in Morris's picture (13). Variety in serpentine uniformity is the principle of organization. Smoke in Fenton's picture and cloud in Adams's picture spell time passing, but in White's version of Snake River we truly enter the world of the atmospheric sublime. The river is no longer serpentine but receives a shaft of light analogous to those several shafts that play prismatically around the mountains. The Grand Tetons are unified in a single impression. The contrast of light and dark has become striking, but clarity has given way to diffusion. Adams is committed to things as they are, White is committed to things for *what else* they are – as he said himself. What else they were included the majesty of the creation but that image was also a mirror of the photographer's soul:

> When the image mirrors the man
> And the man mirrors the subject
> Something might take over.[31]

It is God the Father who takes over. For all that, White was a Kantian idealist beside Adams, the follower of John Muir, an Emersonian realist on the West Coast. John Davies's urbanscape (19) shows how far we have come from Fenton's rural Picturesque: no serpentine line of beauty, but a geometry consonant with our modular age. This is the post-industrial, clean-air sublime. It may be part of a documentary approach to the city of Manchester, but it is more than topographic. The gasometers and the tower-blocks are models for modules: the circle and the square. The grids of the windows, the squares of the fan-lights on the roof of the school, redispose the vertical patterning of the tower-blocks in a different plane; in a unitary series which relates both to the numbered grid on the asphalt and to the parked cars and truck. The oblong cars spill into a half-circle. The children play among circles but apparently live up in squares. The detail of the image articulates the basic geometry to an extraordinary degree. It is impossible not to read the image as a manifestation of Davies's mind and as his social comment on modern society; expressed, however, entirely in terms of camera-work. It epitomizes the popular idiom of frustration: ours is, indeed, a world of round human pegs in square social holes. The result is a good deal more than zero.

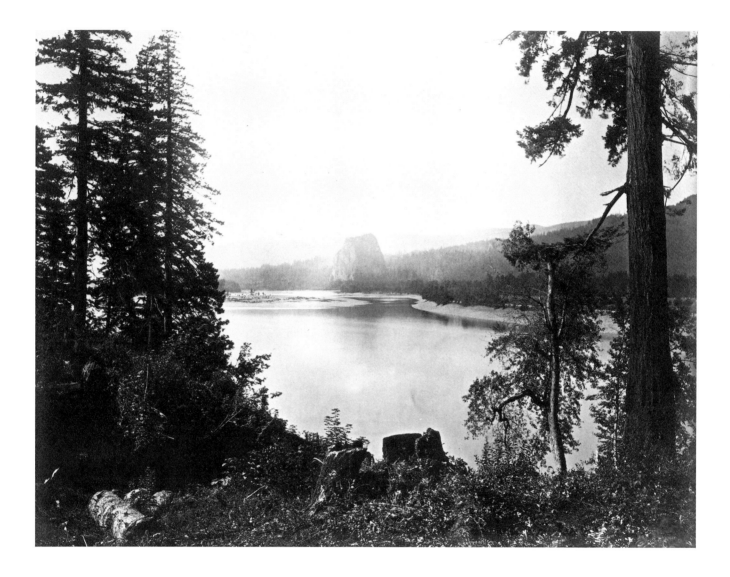

15 CARLETON E. WATKINS, *Castle Rock, Columbia River*, 1867

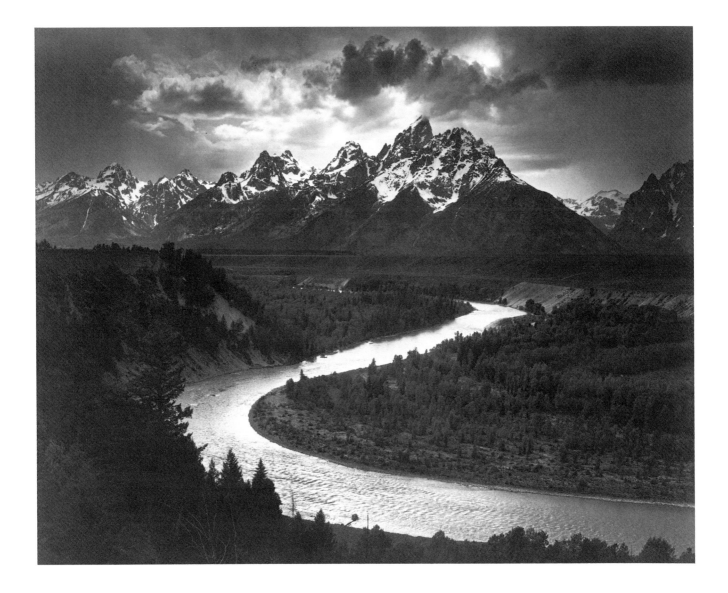

16 ANSEL ADAMS, *The Tetons and the Snake River*, 1942

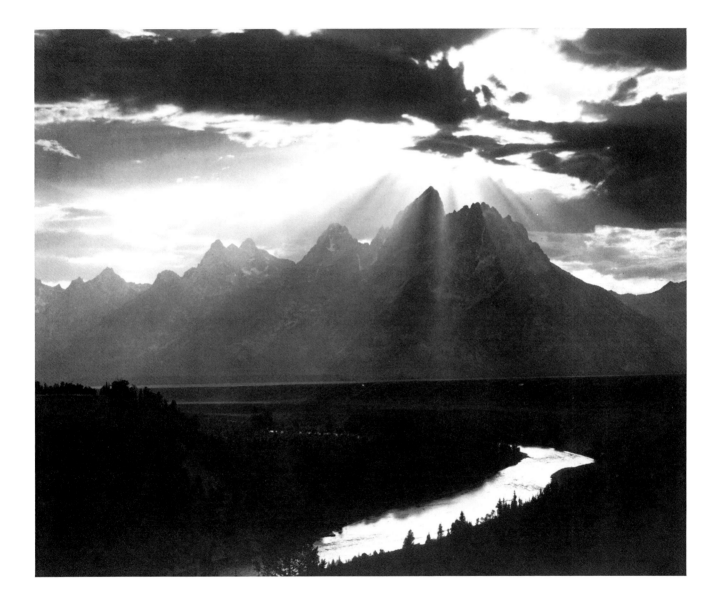

17 MINOR WHITE, *Grand Tetons, Wyoming*, 1959

18 ROGER FENTON, *Bobbin Mills, Hurst Green, c.* 1858

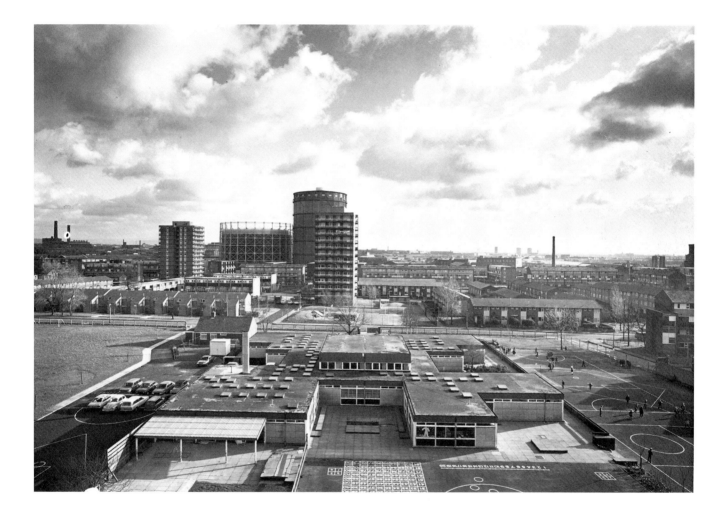

19 JOHN A. DAVIES, *Primary School, Miles Platting, Manchester*, 1984

6. ATMOSPHERIC INFLUENCE

> Candle-light, moonlight, and twilight melt everything
> into one mild hue; through the harmonising medium of
> which, things most offensively glittering, gaudy, and harsh,
> become beautifully rich, splendid, and mellow . . . though
> if seen or represented in the glare of a mid-day sun, they
> would be disgustingly ugly. (Richard Payne Knight)[32]

THE VISIBLE SUNBEAMS over Minor White's mountains (17) percolate through the dense, moist air to produce an effect analogous to the smoky atmosphere of Walter Benington's St Paul's (20). The British impressionist tradition from Turner to Bill Brandt offers an alternative approach to American luminism from Watkins to Adams. Henry James, T. S. Eliot, and Alvin Langdon Coburn – the last of the great American emigrants – supported the impressionist tradition. James praised the London atmosphere for its ability to do just what Knight prescribed. Arthur Symons, whose *Cities* (1903) provided a model for Coburn and Benington, agreed with James:

> English air, working upon London smoke, creates the real London. The real London is not a city of uniform brightness, like Paris . . . The English mist is always at work like a subtle painter, and London is a vast canvas for the mist to work on . . . When the mist collaborates with night and rain, the masterpiece is created.[33]

Benington's dome and spires rise up like cloudy mountain peaks, the distances are magnified, details minimized – as James put it, 'the great city makes everything, it makes its own system of weather and its own optical laws.'[34] What the city makes is a universal aspect which both reflects and appeals to the imagination. It generalizes the scene in order to form an idea or type in the mind. This approach, contrary to the major American traditions in art from luminism to precisionism which are essentially realist in emphasis, is basic to the British. Whistler came to England for it, as did Monet. When Coburn spoke of the 'photographic' he meant atmospheric effect not crystalline precision. Benington was no less precise in his apparent vagueness. The rationality of the neo-classical tradition produced the technology which was the foundation of the British Empire. The Church of England is its epitome. Coburn's picture of St Paul's (21) apparently placed on Waterloo Bridge achieves something different. It is a Masonic emblem: the

Royal Arch with its twin pillars supports the dome of knowledge over the impending catastrophe of the Flood, represented here by the river Thames. Coburn's Dallmeyer telephoto lens serves his Symbolist conception. This symbolist mode, using the general effects of weather, nevertheless conveys a precise idea. While seeming to indulge the ego the photographer disciplined himself to take his place in a larger scheme of things. This is where British and American tendencies combine to produce a formidable joint tradition. Weston knew that Frederick Evans, the English photographer of cathedral interiors, was the founder of the realist tradition in American photography, just as P. H. Emerson and Paul Martin were two great influences on its idealist tradition. Martin's forty-minute, moonlit exposure (22) influenced Stieglitz's New York pictures at the end of the century. The two tendencies, idealist and realist, are in fruitful conflict in the sensibility of the whole person. From one point of view impressionism is empirically descriptive; from another it is broad generalization, as in the expressionist work of Bill Brandt. In his moonlit St Paul's in war-time (23), Brandt treats the view as if it were Kane's Xanadu in the opening sequence of *Citizen Kane* (1940). The broken masonry in the foreground contrasts dangerously with the perfect silhouette of the dome. The buildings to the right, a broken cliff, serve as flats in the theatrical sense. The topographical view is transformed by dark photography into a fantastic stage-set. Exactly the same can be said of luminism except that it transforms by light photography. Caponigro's Stonehenge series combines the two modes. In the picture before us (24), his megalith is treated straight but his sky is an equivalent of the Stieglitz kind. With the aid of moon and sun he hits the mellow moment which is neither harsh nor soft. There is nothing new in combining a moon-rise with a sun-set; D. O. Hill exhibited a painting using this effect. But in Caponigro's version it is not an effect but prescient of the astronomical mystery of Stonehenge itself. It harmonizes thought as well as atmospheric influence. The sun turns everything to gold, the moon turns everything to silver. We are in *twilight*, 'between two lights, or rather, dubious light' (Talbot). Adams's *Moonrise* (25) sets a modest line of buildings against a relatively modest line of mountains, the composition neatly reversing the weight of church and highest peak. The ambiguity of the light is pervasive. The cloud formation could have signified sunset or sunrise. The light striking the crosses in the cemetery appears to come from moonlight, whereas in fact it is coming from the last of the sunlight. Crop away the top half of the picture and the moon with it, and there is no ambiguity – the luminance comes from the sun. Include the moon and, by burning in, lower the white-

ness of the clouds and eliminate others, and the brilliance of the print seems to come from reflected rays of moonlight. The image is a heliograph which poses as a lunagraph. Thus, while fulfilling all the classic requirements of luminism – coolness, stillness, restfulness, and anonymity – it dramatizes, which is counter to the luminist approach. It is not what happened at 4.05 p.m., 31 October 1941, but what Adams thought at that moment, and increasingly thought in his darkroom ever afterwards. The equation made between the mountain peaks and the crosses is at least half illusory, which makes the subject – a graveyard subject, after all – both earthly and unearthly, but neither ghostly not spiritual. It is dramatic but contemplative, atmospheric but calm. This is the sublest version of the sublime. The clouds fly away like vapour, the light touches the crosses. We look up at the mountains (sublime) and look down at the crosses (picturesque), and find the modulation beautiful.

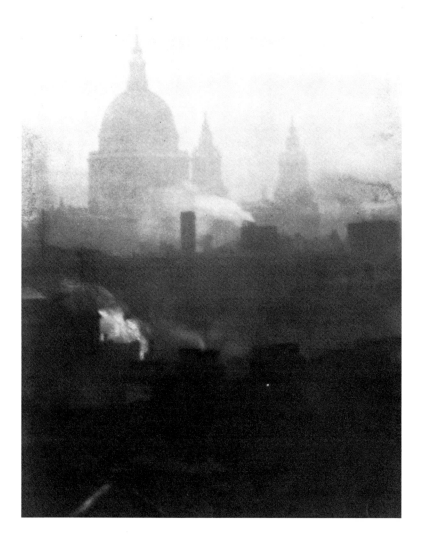

20 WALTER BENINGTON, *The Church of England*, 1903

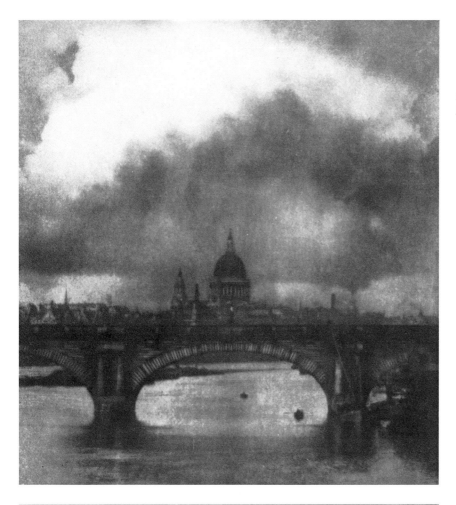

21 ALVIN LANGDON COBURN, *St. Paul's from the River, c.* 1905

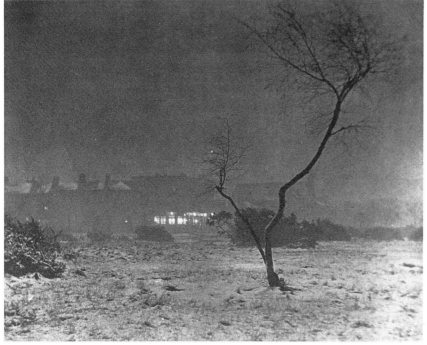

22 PAUL MARTIN, *Wandsworth Common,* 1896

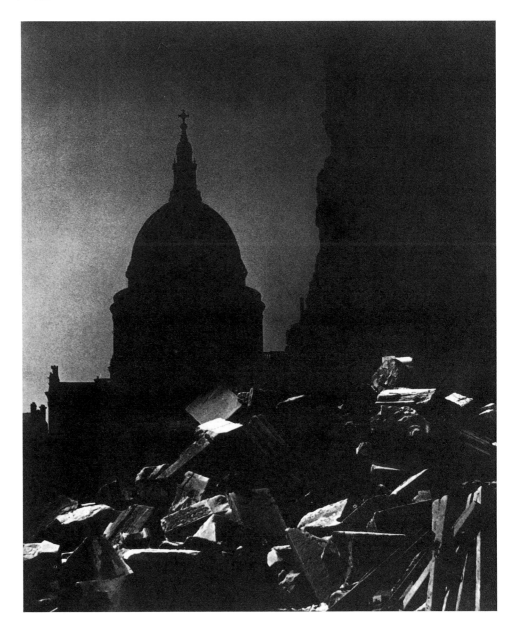

23 BILL BRANDT, *St. Paul's Cathedral in the Moonlight*, 1942

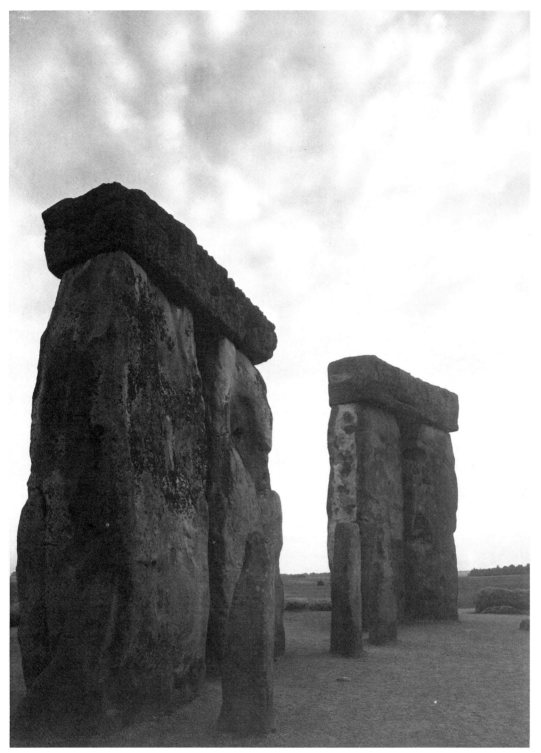

24 Paul Caponigro, *Stonehenge No. 10*, 1977

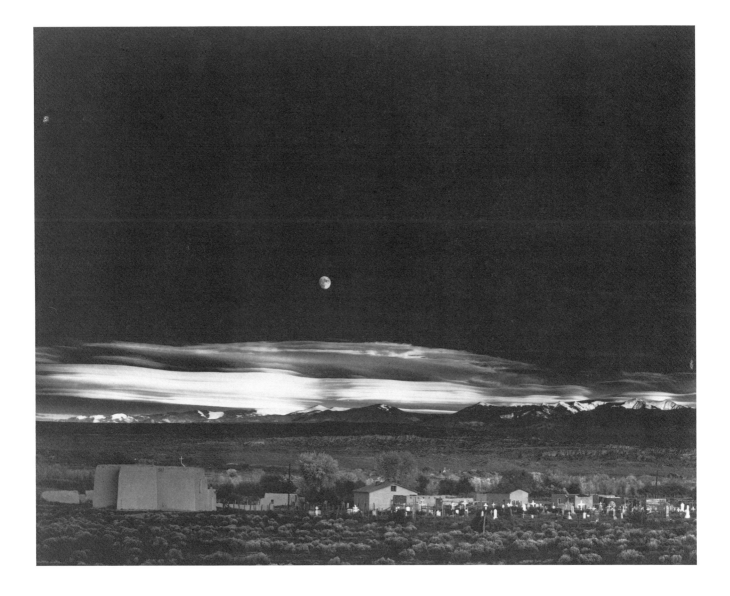

25 ANSEL ADAMS, *Moonrise, Hernandez,* 1941

7. A TRAIN OF THOUGHTS...

The charm of nature lies in her mystery and poetry
but no doubt she is never mysterious to a donkey.
(P. H. Emerson)[35]

ONE ASPECT of the Picturesque was illustrated by particular
instructions to include such animals as had 'loose, shaggy, and
curly hair.' They took their place in among broken boughs,
mossed tree-trunks, and overgrown ruins. Ruskin distinguished
between 'surface-picturesque' and 'fine or noble picturesque'. The true pic-
turesque was defined by Ruskin in moral terms – a combination of Christian
pathos and social conscience with formal excellence, and recognized by

its expression, namely, of *suffering*, of *poverty*, or *decay*, nobly endured by
unpretending strength of heart . . . the look that an old labourer has, not know-
ing that there is anything pathetic in his grey hair, and withered arms, and
sunburnt breast; . . . the world's hard work being gone through all the while,
and no pity asked for, nor contempt feared.[36]

The pictures before us, of sheep and cattle, are almost devoid of human
connection. Avebury is as picturesque a subject as has ever existed in the
British graphic tradition; Paul Nash and Coburn went there; Fay Godwin
has been there by moonlight. The combination of rough stones and shaggy
wool is subject-worthy. But Bill Brandt and Paul Caponigro, in wholly dif-
ferent ways, make something of the combination, and rejuvenate the tradi-
tion. Brandt's work on *Literary Britain* (1951) parallels exactly Coburn's
collaboration with Henry James and Arthur Symons on London in the first
decade of the century. His collaboration, initially with Geoffrey Grigson in
the magazine *Lilliput*, saw completion with John Hayward, just as Coburn's
with Symons materialized finally with Hilaire Belloc. Mark Haworth-Booth
found a key to Brandt's sheep and stones picture (26) in Geoffrey Grigson
quoting Thomas Hardy: 'Nature is played out as a Beauty, but not as a
Mystery . . . I don't want to see the original realities – as optical effects,
that is. I want to see the deeper realities underlying the scenic, the expression
of what are sometimes called abstract imaginings.'[37] Like P. H. Emerson,
Hardy was interested in atmosphere, in two senses of the word – the moisture
in the air, and ambient feeling. In British photography local tones of black

and white are refracted by light and moisture. By comparison, classic American photography has preferred standard illumination of the subject in accordance with luminist principles and with the clear nature of American light. The poetry of things can be induced by a British mystery of presence as well as an American poetry of absence. Brandt's picture, in which trees and stones relate to dwellings of wood and stone, epitomizes the longevity of human settlement. But the sheep ranged on the rise beside the stones polarize the indistinctness of the image by their increasing whiteness. The movement of the sheep breaking forward and away into the foreground completes the picture. The pastoral idea is made familiar and strange at the same time. In Caponigro's picture (27) neither sheep nor farm really figure. Although optically distinct they act as indeterminate background. The image is neither about pastoral life nor about Avebury – it is robbed of cultural context. It is subject-worthy in a different sense. This time the tree and stones do not relate so much to the British Picturesque tradition as to a Ruskinian tradition pursued in America by Edward Weston and Paul Strand: the objects are clearly delineated. But according to another American precedent, of Coburn and Stieglitz in their tree and cloud pictures, they are spaced apart in a metonymic way to put before us apparent opposites, tree and stone. It creates a space in the mind. As the tree gains, by the living ivy, so the eroded stone loses part of its geological and druidical history. The tree religion of the Druids was, it seems, monumentalized in stone: 'On Christmas day it is an old custom, still remaining in full vigour, to dress the churches with branches of the Holly tree; other evergreens are now added' (Talbot). Ivy, holly – they make the tree holy in druidical terms.

In Fay Godwin's Scottish picture (28) the plough is as degraded a picturesque element as Raymond Moore's cartwheels (48). It sets an ironic mood just as the caravans create a feeling of mock-bucolic. The rotary-dryer has usurped the windswept tree – last vestige, with the sheep, of the pastoral ideal. The sheep graze next to a former foundation for a mobile home. Eugene Smith's unpublished *Life* assignment in the Britain of the Fifties parodied, almost, British accounts in the Thirties. His Free Enterprise truck (29), driving cattle in an age of nationalization, expressed a thoroughly American, individualist sense of irony. In John Ford's *Grapes of Wrath* (1940) the Joad family's jalopy carves its way through vigilantes, migrant workers, and other flocks of sheep. The individual free will of the family must prevail. Cattle are to be driven. This was not what the Labor government had in mind, of course, but Smith expressed it, as he no doubt felt it, in such an image.

26 BILL BRANDT, *Avebury*, 1945

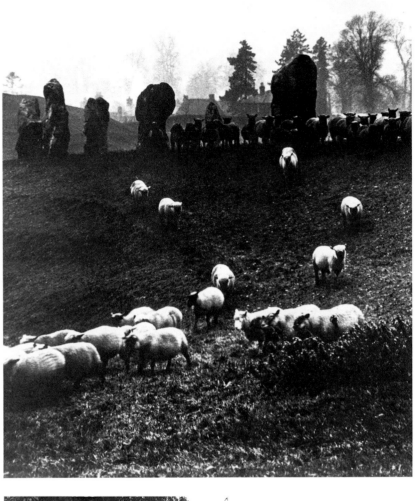

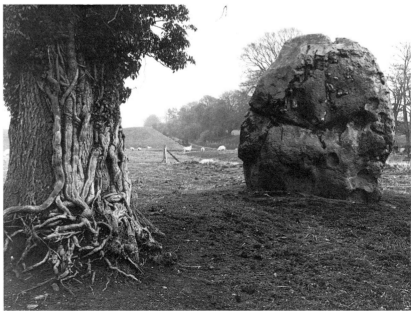

27 PAUL CAPONIGRO, *Avebury*, 1967

55

28 FAY GODWIN, *Kilchoan,
Ardnamurchan Peninsula*, 1983

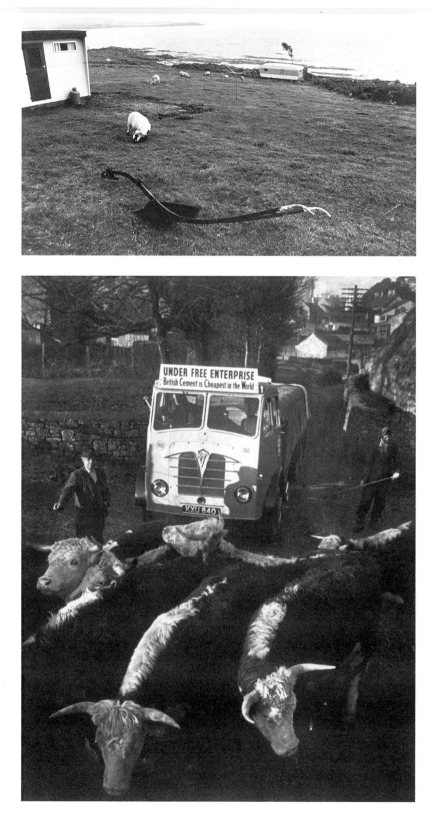

29 W. EUGENE SMITH, *Under Free
Enterprise*, 1950

56

8. . . . AND FEELINGS

Labour; by sea and land, in field and city, at forge and
furnace, helm and plough. No pastoral indolence nor
classic pride shall stand between him and the troubling of
the world; still less between him and the toil of his
country, – blind, tormented, unwearied, marvellous
England. (Ruskin)[38]

TURNER'S *Frosty Morning* (1813) (fig. 7) belongs to a genre involving horses and carts. Its foreground includes a wheelbarrow, pick, and spade which are both decorative and emblematic. Its tree belongs to the same type as Paul Martin's (22). Yet the figure of the little girl may be modelled, we are told, from one of Turner's natural children, and the man with the gun and the boy further off may be his friends. The workmen are less engaged in labour than paying their respects to the rising sun that will thaw the frost, in illustration of a line from James Thomson's *The Seasons*. The second horse, free of harness, grazes a cold earth. P. H. Emerson's picture (30) is composed in the same manner, with the pairs of cows on either side of the cart matching the two figures on either side of Turner's. The dog is analogous to the loose horse. But Emerson has also done something different: he has not stilled and separated the two workmen like Turner, but related them as one – in movement, epitomized in pikework. The pike of the man pitching intersects with that of the man leading the horse so that they meet, still and moving, in a blur of hay. The men are playing doubles, with the dog for audience. It is no accident that Emerson was a good billiards-player ('All flukes count to the delinquent's opponent').[39] This is no fluke to a man whose work is full of such poles, pikes, and – cues.

Ruskin wrote: 'A delicately taken photograph of a truly Turnerian subject, is far more like Turner in the drawing than it is to the work of any other artist; though, in the system of chiaroscuro, being entirely and necessarily Rembrandtesque, the subtle mystery of the touch (Turnerism carried to an infinitely wrought refinement) is not usually perceived.'[40] James Craig Annan's *Stirling Castle* (31) fulfils all Ruskin's requirements, including the Turnerian touch. Ruskin was writing before the time of Annan's photogravure – the true successor to the mezzotint in the British tradition,

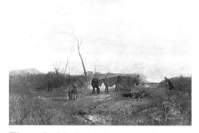

Fig. 7 J. M. W. TURNER, *A Frosty Morning*, 1813 (Tate Gallery, London)

Fig. 8 J. M. W. TURNER, *Castle Above the Meadows, c.* 1808

Fig. 9 J. M. W. TURNER, *The White Horse, c.* 1808

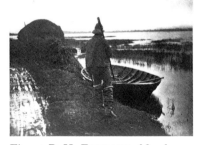

Fig. 10 P. H. EMERSON, *Marshman, Norfolk Broads, c.* 1886

which influenced Stieglitz's reproduction of images in *Camera Work*. That it is a Turnerian subject we cannot doubt. It is a composite image of Turner's *Castle Above the Meadows* (fig. 8), and *The White Horse* (or The Straw Yard) (fig. 9), adjacent prints in the *Liber Studiorum* (1808). Annan's picture thus combines Claudian pastoral with rural genre to make it more of a cultural statement than Turner's exercises. There is a social and historical relation between the castle on the rock with its battlemented white clouds and the farm-yard – gate off its hinges against a wall, straw shed half-open to the elements – with its white horse, back shining white, head half in shade. Neither pastoral nor classic but modern, the horse is neither weary nor wearied, neither sleeping nor awake, as unharnessed as the clouds but irrevocably joined to the castle. Strand's white horse (32) is as suggestive of American society as Annan's is of Scottish: not a cart horse, but haltered as Annan's is not; no castle, but fenced in all the same. Hill and Adamson's fence and tree (10) are typified here as a gate hung upon a pole. The leanness of the horse and the barbed wire express Strand's subdued feeling all too well.

George Davison's horses and drivers (33) seem, at first, to be casually arranged, but they are standing in a shallow triangle with the man with his back to us, feet apart, coat slung over his shoulder, at its apex. He is in the same position as the figure in Stieglitz's New York picture (34). Davison's picture has a *plein air* quality, which transports us to the world of Courbet, sombre but heroic. This group of men is actually plunged in the great agricultural depression of the eighteen-eighties when putting arable land down to grass threatened the ploughman's very existence. How much expression there is in a man's back! See what Emerson can do with a marshman (fig. 10), and what Stieglitz can do with his teamster. It is a position which imaginatively places us in the picture as participant, observer, and victim simultaneously. In the examples cited so far it tends to passivity, essentially wearied and tormented if not blind. A figure from the back, centred in the frame, carries this pathetic resonance at some deep level of pictorial consciousness.[41] But in Emerson's great picture, *A Stiff Pull* (35), the blurred movement of the figure, the horses breasting the hill, the lowering cloud, an absence of trees by which the image would be otherwise pastoralized – all this contributes to an image of force as well as strain, of endurance as well as pain. What more can you hope of a man but that he keep his head above the horizon line?

58

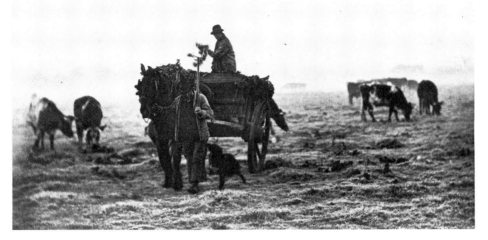

30 P. H. EMERSON, *A Frosty Morning*, c. 1888

31 JAMES CRAIG ANNAN, *Stirling Castle*, 1906

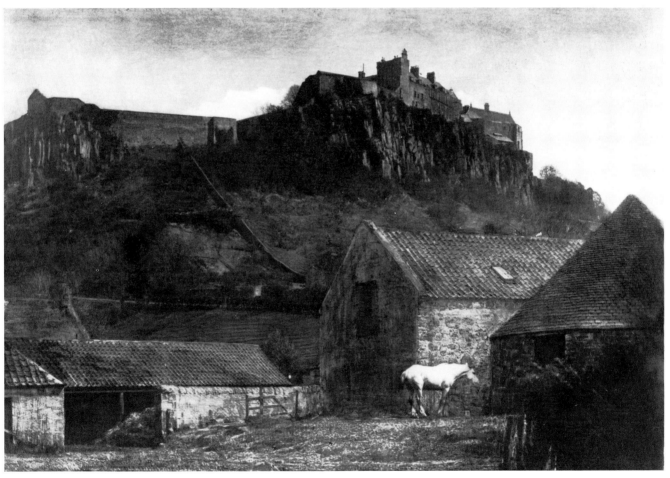

32 PAUL STRAND, *White Horse, Ranchos de Taos, New Mexico*, 1932

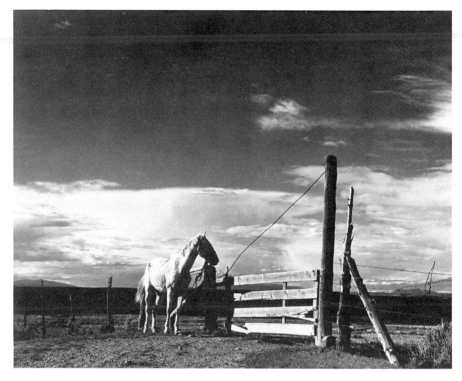

33 GEORGE DAVISON, *Berkshire Teams and Teamsters*, c. 1888

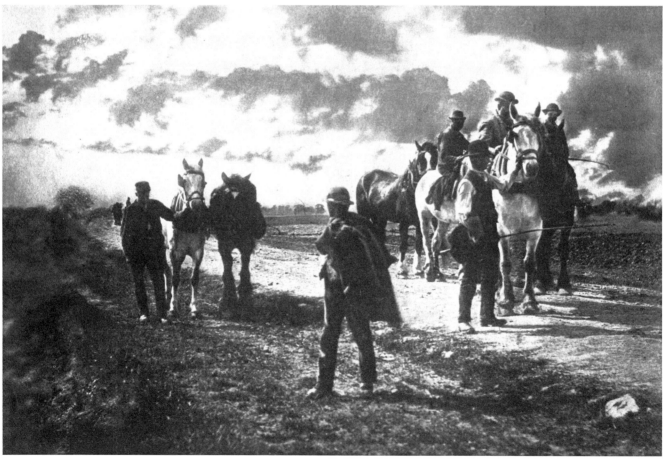

34 Alfred Stieglitz, *The Terminal, New York*, 1892

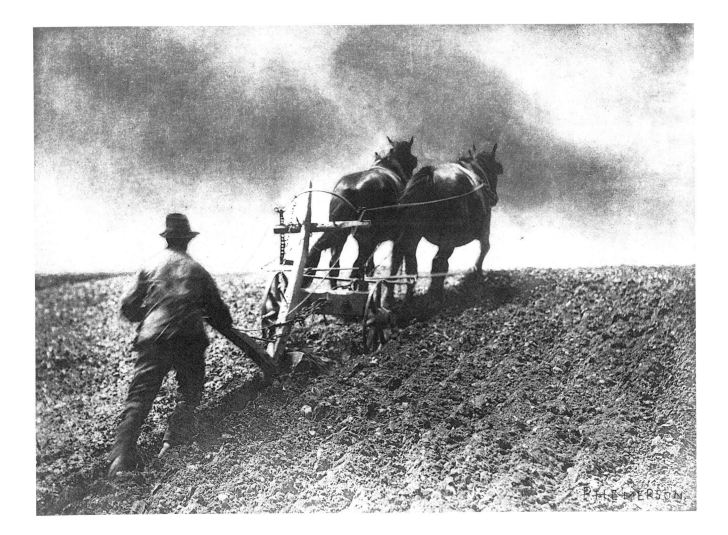

35 P. H. EMERSON, *A Stiff Pull*, c. 1888

9. CONCERTED ARRANGEMENTS

It is commonly supposed that the word DRAMA, by which
we denote a theatrical representation, meant originally *a
thing done: an Action* . . . this is plainly what a *dramatic*
representation is NOT. It is not *a thing done* – it is a thing
merely simulated *or* pretended. (Talbot)[42]

THE MOTIVATION for the work of Hill and Adamson was largely
historical, and the Church Question in Scotland their great sub-
ject. They prepared for Hill's huge picture of the Disruption by
making photographic portraits and group pictures. The
Presbytery group (36) can be a conversation piece. Neither historical nor
unhistorical it shows a standing group of men listening attentively to a seated
person who reads from Hugh Miller's newspaper, *The Witness*, voice of the
Disruption movement. The relaxed poses, the youthfulness of two groups
pyramidically arranged, the absence of Dr Thomas Chalmers, their father-
figure, gives the picture an intimate and comradely air. 'Designed and
aranged' by Hill, to use his own description, it transposes the usual conversa-
tion piece of connoisseurs gathered around a picture, to include an egalitarian
activity of religious and social debate. The newspaper is the centre of
attention.

Somewhat unexpectedly, if the feeling of Hill's picture is social, Paul
Strand's group (37) is immediately perceived as religious. *The Mexican Port-
folio* (1940) by Strand, a committed Marxist, is entirely Christian in tone.
But then his film *Native Land* (1938–42), made with Leo Hurwitz who wrote
the introduction to the Mexican portfolio, also employs biblical as well as
historical typology. Like the painters of the Mexican mural Renaissance,
Strand realized that the deepest responses to the tragic plight of the people
would be evoked only by Christian references. Dr Atl, revolutionary leader
of the painters, complained that no matter how they fought the clergy the
revolutionists remained Catholic. So Strand's picture is a kind of *retablo*
divided as a diptych. Of the two women framed in the doorway one bare
foot projects over the threshold like an image of Christ's does in another
of Strand's Mexican pictures. The combination of painting, sculpture, and
architectural elements in Mexican altarpieces make a *Calvario* more like a
theatrical construction. The backdrop here includes foliage, wooden doors,

and a stucco wall. This is a *sacra conversazione*: we see two Virgins, at different stages of the story. The one carrying a child is anonymous and adoring – a *Madre pia*. The other, older one carrying the cup (the wine) and the bundle (the bread) is a doleful witness of the Resurrection. Seen as a whole rather than as a diptych, the picture is essentially of the Three Marys plus the anti-type of Mary with the child.

Compare Josef Koudelka's picture (38) with Annan's (39) in terms of the mountain top. To Koudelka the elevation is important, but the second group behind the kneeling men is also important. They touch each other and look at the same view whereas the three men, like Strand's figures, are alone with their interior vision. In a conversation piece there should be a joint response. The background group shows such a response but they appear more like tourists than pilgrims, and are oblivious of the three men, whose faces and gestures reveal the motions of their souls: the one on the left, determined, uses his stick like a paddle; the one on the right is as sceptical as a shepherd; the one in the middle sorrowful or depressed. Typically (not literally of course), they re-enact the knee-breaking experience of three men at Calvary.

Annan's picture (39) turns the emphasis away from people towards the mountains. The men are of the Emersonian type seen from the back (fig. 10), but they are also stand-ins for us, headed towards the darker and greyer distances. Stieglitz made this the first image he collected from a contemporary. Perhaps he saw it as a Romantic landscape in the tradition of Caspar David Friedrich. Annan was a master of such pastiche in several styles, all done with equal conviction to great effect.

Raimondi's engraving (fig. 11) shows how well placed in the pictorial memory are the statues of three men. We identify with the fate of a fourth man reaching up a hand. The climb from below is the apex of a hope otherwise expressed by the pyramidal shapes of figures, dwelling, and distant hill, threatened by the oncoming soldiers. Eugene Smith's trio (40) is not threatened so much by soldiers as by a uniform environment of industrial housing. The three figures express Ages of Life; boyhood, maturity, and age. The cigarette and the masks, not from some charade but from life underground, stop any false sentiment dead. These men defy the environment as one man, the focus of whose look is upon us. We are the oncoming soldiers, they are the climbers. What do we intend to do about it?

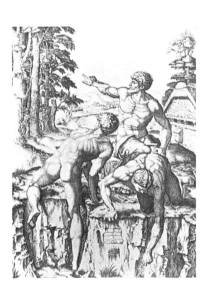

Fig. 11 MARCANTONIO RAIMONDI, *The Climbers*, 1510

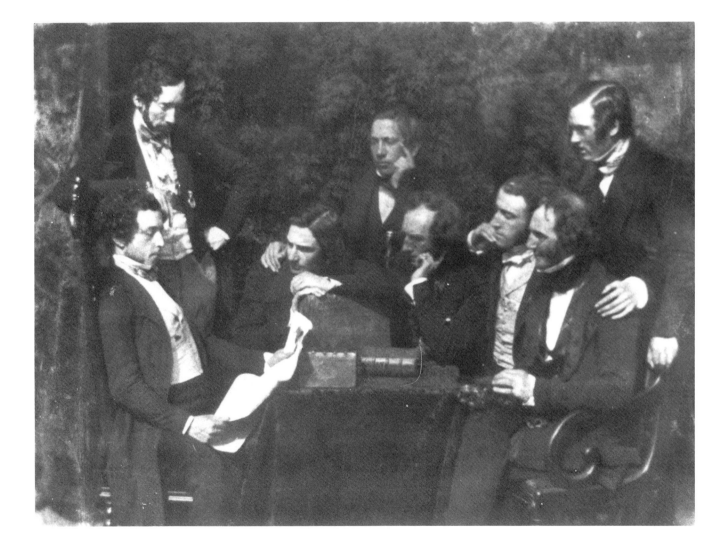

36 D. O. HILL and ROBERT ADAMSON, *Presbytery Group, c.* 1845

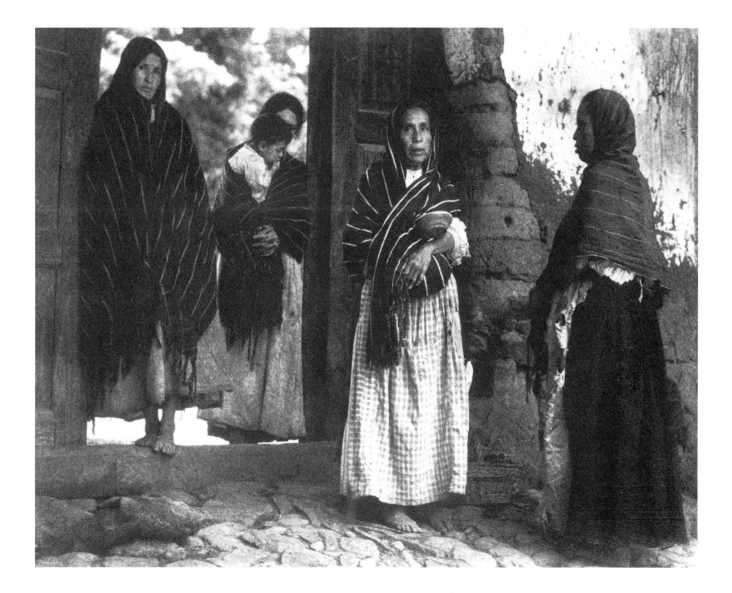

37 Paul Strand, *Women of Santa Anna, Lake Patzcuaro, Michoacan, Mexico*, 1933

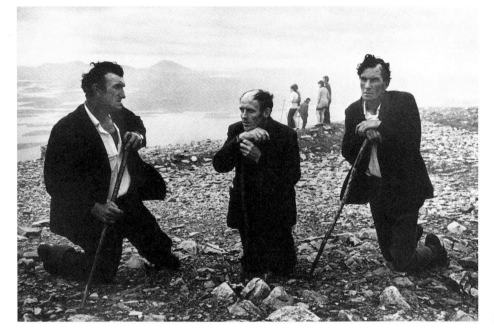

38 JOSEF KOUDELKA, *Ireland*, 1972

39 JAMES CRAIG ANNAN, *The Dark Mountains*, 1890

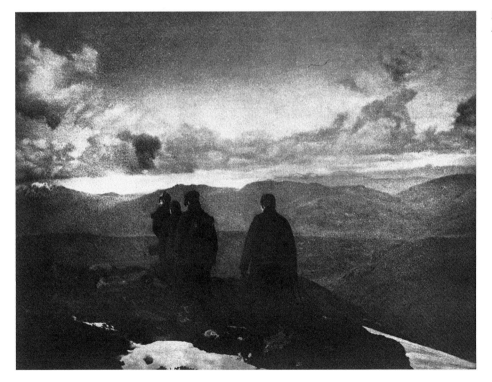

67

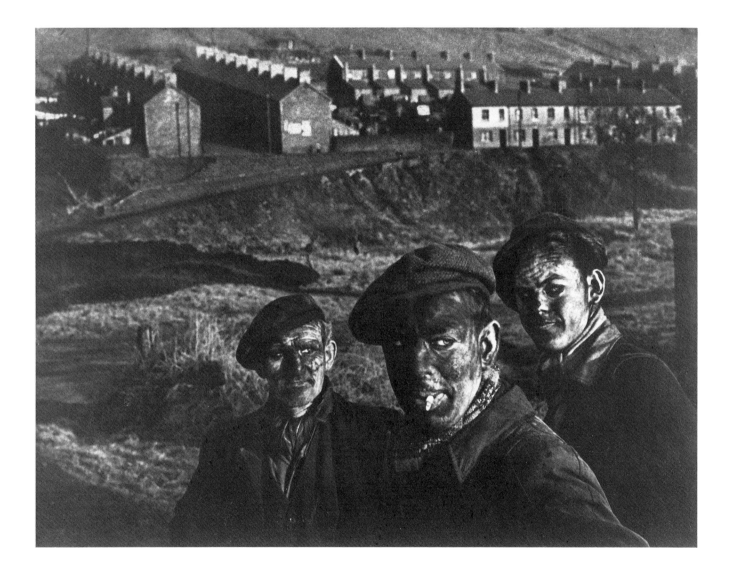

40 W. EUGENE SMITH, *Welsh Miners, Wales,* 1950

10. THE INJURIES OF TIME

Ruined buildings, with fragments of sculptured walls and
broken columns, the mouldering remnants of obsolete
taste and fallen magnificence, afford pleasure to every
learned beholder. (Knight)[43]

BROKEN FORMS produce arrangements of light and shade of varied kinds which offer a ready challenge to the draughtsman and are a gift to the photographer. But on its own, abstracted from all referents, this texture, this surface-picturesque, offers no reward to the Associationist mind, which seeks its pleasures in history, society, and metaphysics. B. B. Turner's castle (41) is filling up with stones on the inside. The building is going back to rubble. The usual associations have to do with weeds and ivy, but here the building is choked – with stone.

Hill and Adamson's view of John Knox's house (42) needs historical association, as well as a Picturesque understanding of the cart and exterior staircase. The neighbouring house fell down in 1840, and the Free Church of Scotland (the Disruption church) bought Knox's house in a ruinous state in order to save it. Hill's sketches and painting of the Disruption events followed a tradition of church-history painting stemming from David Wilkie's pictures of Knox preaching and dispensing the sacrament. Hill's immense Disruption painting played down the preaching role of Dr Thomas Chalmers, leader of the movement and chaplain to the Royal Scottish Academy, but included pewter communion plate prominently in the foreground. To Hill, Knox's house was a symbol of the struggle of the Free Church. The cart and staircase are Picturesque elements which may bear some of the weight attributed to Talbot's carts and ladders. In J. M. W. Turner's watercolours such foreground elements play a part in the larger view, but in Howlett's close-up (43) a cart becomes an essential rather than an accidental element, and the character of the object emblematic rather than quotidian. At the level of sensation, as understood by the late eighteenth century to mean sensory perception, a cart is a cart, but in terms of association of ideas a cart is related to all the carts in art history. Association adds continually to observation to become a kind of improved perception, a kind of cultural knowledge.[44] The gradual way by which we grow as human beings possessed of natural and artificial memories leads to the association of ideas. By means

of improved perception the familiar is made special. Gradually, much comes to depend upon such a cart in all its quiddity beside a limpid stream. Mill-wheels, grindstones, and cartwheels begin to mean something according to the cultivation of the perceiver's mind. For some, the wheel brings Nemesis, Fortuna, Ixion, and Sisyphus in its train of ideas. To others, wheels are merely wheels. But, universally, the idea of the passage of time is evoked in the turning of the world represented by a wheel – even in Raymond Moore's ironic comment on the modern use of the cartwheel as garden furniture (48).

Edward Weston's car (44) was once a wheeled vehicle. Now it is wrecked, in the American sense of smashed and in the English sense of beached. It is so totalled there are no wheels visible, so that the type *car* is destroyed. All that is left is patina and atmosphere. Godwin's picture (45) shows the wrecking less complete. The steering wheel, at least, is still in place, and a notional wheel, cast hoop-la fashion, decorates the raised bonnet. It is wrecked and bedecked at the same time.

41 B. B. Turner, *Causeway and Entrance, Ludlow Castle, c.* 1852

42 D. O. HILL and ROBERT ADAMSON, *John Knox's House, Edinburgh, c.* 1845

43 ROBERT HOWLETT, *In the Valley of the Mole,* 1855

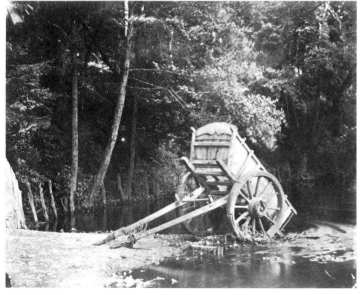

THE INJURIES OF TIME

44 EDWARD WESTON, *Wrecked Car,
Crescent Beach*, 1939

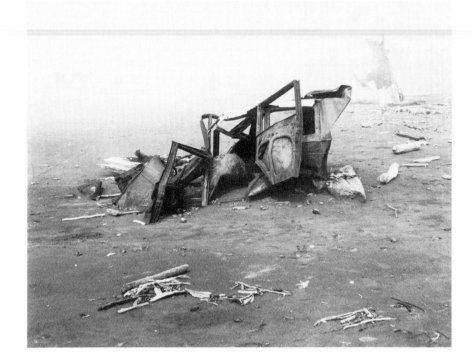

45 FAY GODWIN, *Rotting Car,
Cliffe Lagoon*, 1982

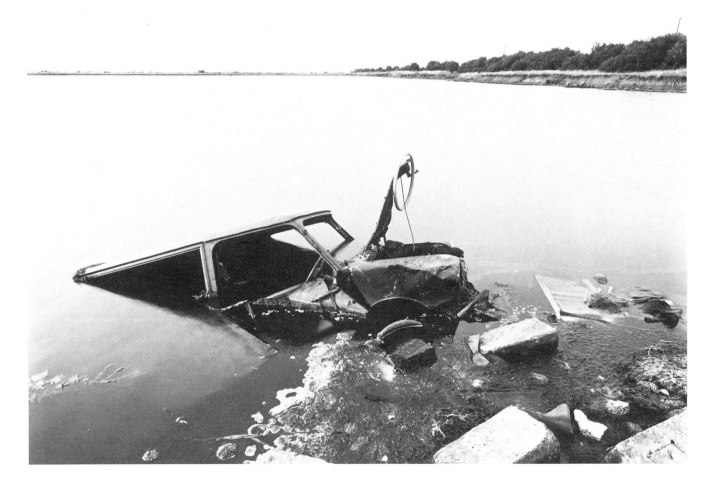

II. PRINTED PLACARDS

I think it probable that the word *Thing* (Germ. *Ding*)
may have originally meant a *word*: i.e. any thing *we may
chance to speak of*, and that it may have been identical with
the old Latin *dingua* (for *lingua*) mentioned by some
writers. (Talbot)

THERE ARE FEW THINGS about which we will not have ideas, but,
equally, there are few ideas which cannot be attached to things.
When Walker Evans wrote that photography seemed to be the
most literary of the graphic arts he meant it had rhetorical features of paradox, wit, and play available to it on the basis of association.[45]
He was also proposing that the billboard poster, the commercial advertisement, and the street-sign could be read like any other form of writing as
an ironic construct. It becomes a thing subject to associational response.
In the version of the Art School picture which Evans cropped himself (46)
he wittily juxtaposed the idea of what the general said with what a reporter,
then or now, might take down: the treatment of actuality, whether in art
school, journalism, or photography remained problematical. In the print
from the original negative (fig. 12) paradox is less restrained, and the unwitting contradictoriness of the image achieves oxymoronic proportions: the
folk-art representation of the fruits and vegetables is clearly at odds with
the claim that this is an art school. Ken Phillip's bicycle sign (47) requires
verbal completion. The name, of course is RALEIGH, synonymous with
adventure in the New World. The rider waves gaily, the sun kisses his front
wheel, but the metal bar, the twigs, and the rusty corrugated iron tell us
that the Empire has long since been swept away. It is a wistful rather than
witty picture. Moore's village street scene (48) ironizes the whole concept
of the Picturesque. Plaster gnomes and animals, barrel-halves and horse-hames, wagon-wheel and plough are all presented against a medley of
modern wall textures – pebble-dash, breeze-block, and whitewashed stone.
Rubbish bins separate these elements from a mongrel puppy – a black,
melancholic emblem of the starved senses. It sniffs in search of real rubbish,
hopelessly.

Emmet Gowin's picture (49), to those who know his other work, is a
portrait of his wife: EDITH, it reads. Only her shift is now a proxy for her
body, and the light of his life is her head. But the diagonal cable which runs

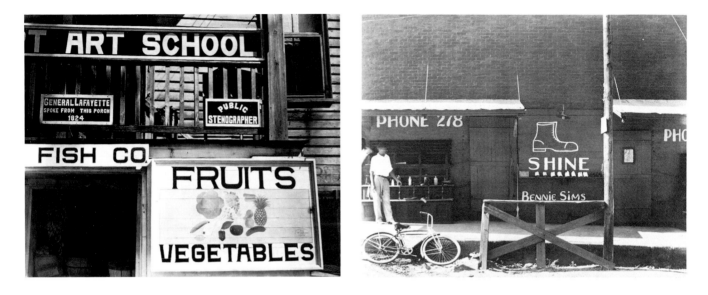

Fig. 12 WALKER EVANS, *Beaufort, South Carolina*, 1936 (Library of Congress, Washington D.C.)

Fig. 13 WALKER EVANS, *Southeastern USA*, 1936 (Library of Congress, Washington D.C.)

across this story and intersects the light-cable above the bulb threatens the domestic scene like a cancellation mark, and relates, uncomfortably, to the empty hooks to the right of the picture. The light could be switched off. Walker Evans' shoeshine stand also has a light-bulb, only it is midday and it is not yet needed to illuminate the sign (50). In Evans' first version from across the street there is a clutter of objects set within a kind of grid (fig. 13). Bennie himself stands in front of his black and white bottles, his bicycle represents his mobile service, and the hitching rail underlines his name. Our closer version edits out everything except the overhead light, the white and black shoes, and Bennie's name. The word SHINE dictates the arrangement of the shoes which themselves objectify its meaning. Alternatively, the shoes are an Alabaman hieroglyph of the word SHINE. Sparkling white they point to the feet of the white letters and express them spatially (H, N, and E get two shoes on account of their width). Two black shoes bring the word to a full stop. The picture of the shoe (the image), together with SHINE (the word) and the shoes (the objects) combine to represent in three languages an idea – a flash in Bennie's mind without benefit of artificial light. Of course, he signs it – it is his work of art.[46] Ralph Waldo Emerson once wrote that there was no object so foul that intense light would not make it beautiful,[47] but that light is of the mind as well as of the sun. The traditional emblem of such illumination is the candle, the lamp – or the light-bulb.

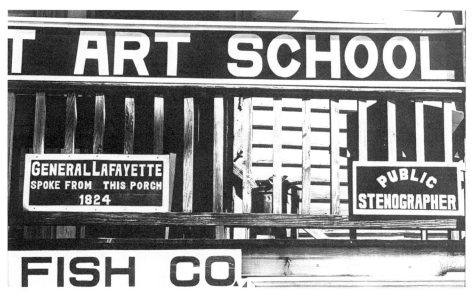

46 WALKER EVANS, *Beaufort, South Carolina*, 1936

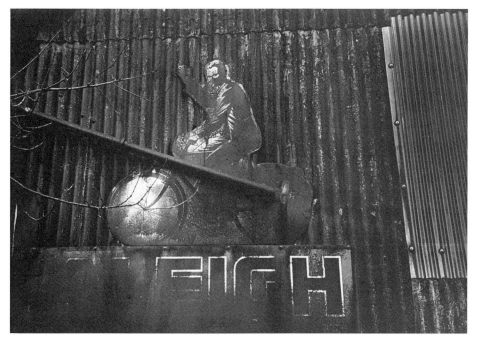

47 KEN PHILLIP, *Castle Caereinion, Wales*, 1975

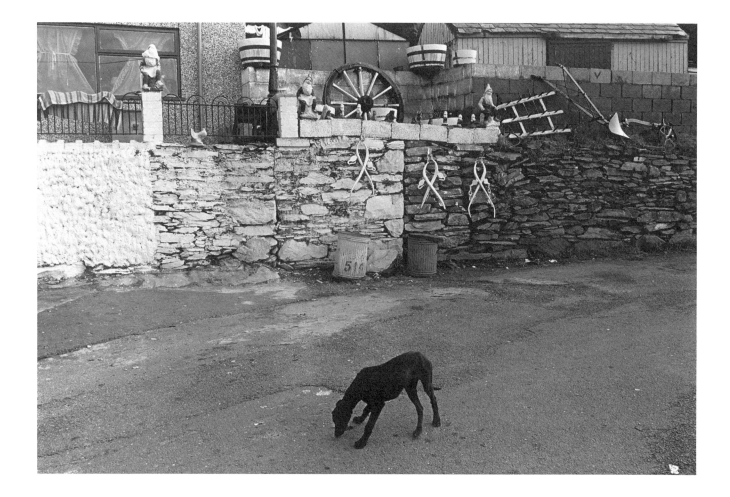

48 RAYMOND MOORE, *Blaenau Ffestiniog*, 1973

49 EMMET GOWIN, *Danville, Virginia,* 1971

50 WALKER EVANS, *Southeastern USA,* 1936

12. UNWRITTEN TRADITION

How gladly would we exchange Droeshut's engraving and
the bust at Stratford for a photograph of Shakespeare!
(J. A. Symonds)[48]

Fig. 14 ALESSANDRO ALLORI, *St. John the Baptist*, 16C (Glasgow Art Gallery)

ALVIN LANGDON COBURN'S picture of Clarence White (51) is not a straightforward portrait but a Symbolist evocation of White as John the Baptist. A visit to the Italian room of the great city art gallery in Glasgow swiftly proves the point. There you can see John in the wilderness with his Christian attributes of cross and halo, but offering the cup in a gesture which, combined with his leopard skin, seems as much bacchic as baptismal (fig. 14). By the time Coburn portrays White in this way the attributes of identification are gone. Fred Holland Day's Nubians carry a thyrsus instead of a cross; Robert Mapplethorpe's a spear. Coburn, unlike them, did not subscribe to the Decadent tradition but remained a Christian quietist.

The portrait of Alfred Stieglitz by Paul Strand (52) embodies the two poles of aesthetic experiment in the twentieth century, the realist and idealist approaches. Stieglitz's eye-glasses relate to his eyes in the same way that the gnarled tree does to the house. On the wall of the house a dark window with an off-centre circle of blurred light relates to Stieglitz as conceiving, abstract brain, and on the gnarled trunk of the trees a glistening knot-hole relates as an eye to Stieglitz's sprouting, real body – the faun with hair in his ears. Charles Demuth, the American painter of the Stieglitz circle, was fond of combining houses and trees, the abstract and the organic, in this way. Edward Weston's Armco Steel chimneys and pipes do the same to emphasize tree-forms, as Charles Sheeler's painting of clapboards suggests the cubist forms of the house. In short, Strand has portrayed Stieglitz as the nexus of the movement which in the United States is known as Cubist-Realist or Precisionist.

The Precisionist painters never issued a manifesto but it is fair to say that they were as much formalists as realists – more interested in structure and relations than in symbols or metaphysics. But their interest in forms was complemented by an unusual devotion to things, real as well as constructed. They avoided the anecdotal while keeping to the objective tradition of nineteenth-century Realist art collected by the Downtown Gallery owned

by Edith Halpert in the nineteen-thirties, the source of both Sheeler's interest in the Shakers, and Walker Evans' enthusiasm for vernacular American art. Sheeler called it 'selective realism', the poets called it Objectivism, but it was in many respects a reprise of the movement, led by Ezra Pound in the period before the First World War, called Imagism. Polemically speaking, Pound's Imagism was a recoil against Symbolism at the high-point of the philosophical debate between Idealism and Realism. In the long run Pound was himself an idealist, but in 1913 he was posing as a realist. William Carlos Williams, his friend, was by comparison a realist who occasionally fell back on idealist notions (his famous Red Wheelbarrow poem can be read both as a description of things and an objective correlative of an emotion). Sheeler, the painter-photographer, summed up the situation in the thirties in a definition which described the intrinsic realism of photography and essential idealism of painting: 'Photography is nature seen from the eyes outward, painting from the eyes inward.' Poetry represented the inner spirit like painting, while prose, like photography, represented the outer fact. But, as Pound exhorted the Imagists, it was the duty of poetry to be at least as good as prose.

William Carlos Williams thought that Precisionism could all too easily become prim and over-careful. Of Sheeler he wrote that someone should smash his camera and open his brain. Selective realism was becoming empty realism untouched by mind.[49] Avedon's portrait of Williams with Pound marks that evening in July 1958 before the ex-inmate of St Elizabeth's Hospital, Washington, quit America never to return (53). Talbot: 'In the proverb "*penny* wise and *pound* foolish" the two words are used as a strong contrast. It is curious to observe that anciently a penny and a pound were nearly the same; the Saxon *peneg* meaning a *pound-weight*.' Pound, the dandiacal prophet, had by then become the bearded wiseacre and wizard. Wrinkled, crinkled and clawed, he leans like some demon on the college friend who was his complement – Williams, most lovable of all the American poets, one hand in his pocket, penny-wise and open-faced. Pound's right hand, adroit but cunning, is set against Williams' left, sinister but innocent: in for a penny, in for a pound. We have to take them both.

51 Alvin Langdon Coburn, *Clarence H. White*, 1905

52 PAUL STRAND, *Alfred Stieglitz, Lake George, New York,* 1929

53 RICHARD AVEDON, *William Carlos Williams and Ezra Pound*, 1958

13. A HOLY SISTERHOOD

I long for the great day when English Art
 Shall be the outcome of the English race,
 When every woman shall have Venus' face
And the Madonna's beauty, and her heart.
 (James Hinton)[50]

CLARENCE WHITE, Coburn, Frederick Evans, and P. H. Emerson all acknowledged Julia Margaret Cameron as their great forbear in photography. She gave this Anglo-American tradition of pictorial photographers its foundation. But that base rested firmly on a religious footing – Cameron was a typologist. She read the Old Testament of the Bible in terms of the New to make connections between various characters and events. In this way the Old Testament could be interpreted as prophetic of the New, but the method could also be extended to classical mythology, and the English poets. Cameron's work really draws upon four testaments: Old, New, Classical, and British. The principal contributors to the British were Shakespeare, Milton, Keats, and Tennyson. Typology is less rigid than allegory where one thing stands for another in a fixed manner. It develops over time, constantly incorporating new types. Noah is a type of Christ; Tennyson is a type of King Arthur. It represents an evolutionary view of human history from a Christian point of view.

Eveleen Tennant Myers began work in photography in 1888 with the aim of making portraits of her children, but she also treated biblical subjects like Rebecca at the Well, Raphaelesque subjects like cherubs, and made portraits of Browning and Gladstone. Her picture *The Summer Garden* (54) is of her children but it is not simply a family portrait. The scene is an Edenic setting, shortly before the Fall. The skirt caught up to reveal lace, as the girl reaches for the apple and the boy glances up at her, evokes man's first temptation. This typical method was, by 1900, absorbed in the Symbolist movement in art, and no longer received detailed Biblical interpretation. A multiplicity of meanings entered into a comparative religious tradition at the beginning of what has become a post-Christian era. But Clarence White's picture of women picking apples (55) is a complex, Symbolist image still best appreciated in terms of types: in Raphael's *Three Graces*, the

daughters of the Sun hold apples like the daughters of the Night, who are the guardians of the golden apples of the Hesperides; and the harvest, in Rubens and Poussin, is a type of maturity, but also of the Passion. In White's picture one woman kneels tenderly to retrieve the bruised fruit of the tree, like Mary at the foot of the cross with her two companions:

> What luckless apple did we taste
> To make us mortal, and thee waste?
> (Andrew Marvell)[51]

In Gertrude Käsebier's picture (56) there is a painting – on the wall in the background – of a subject which appears to be the Visitation, the moment when Elizabeth, mother of John the Baptist, shares knowledge of divine pregnancy with Mary. This threshold scene suggests an uncertain step forward for the young girl towards her foreshadowed destiny as the mother of Jesus. But has not Käsebier made the child too young? No, she is working in typological time which is synchronic: the girl is simultaneously evoked at her Presentation in the Temple and at the Annunciation, as well as at the Visitation.

Cameron's picture of two women (57) is polytypical to an extraordinary degree. Its meaning combines the head alignment of Mary and Elizabeth at the Visitation, with that of John and Jesus as young children (fig. 15), and that of Mary and the dead Christ of the *pietà*. Its fused emotional meaning thus comprises feelings of protectiveness, affinity, and grief. The title, *The Kiss of Peace*, refers to the moment in the Eucharistic ritual when women embrace. In the next image, also by Cameron (58), the same model who represents Elizabeth, Mary, and St John, represents the sinful side of the Christian story. The title suggests the male angel who appears at Christ's tomb at the Resurrection, 'His countenance was like lightning, and his raiment white as snow' (*Matthew*, 28:3). But Cameron has transposed the lightning flash of glory to the face and hair of Mary Magdalene, whose loose hair is the attribute of a legendary, fallen woman who was, nevertheless, the first person to whom Christ appeared at the Resurrection and thus confirmed the Christian doctrine of the priority of the saving of sinners. Cameron was a typological feminist, an artist of genius, who was capable of expressing psychological insight into the nature of relations between men and women in a pre-Symbolist manner.

Cecil Beaton's Garbo (59) extends the typological memory-system to include Hollywood, which has been supplemented in our contemporary

period by the stars of popular music. Cameron would have sensed that Garbo's leonine hair placed her with the Magdalenes. Transfixed as before a firing squad, damned by the dark shadow which is the projection of her *anima*, the polo-necked sweater and the suit bear out that own view of herself when she remarked to Beaton, years later: 'You should have taken me by the scruff of my neck and made an honest boy of me.' Garbo takes her place in a tradition to which Dietrich, Hayworth, Crawford, and Janet Leigh belong – *femmes noires* in *films noirs*.[52]

Yoko Ono is an addition to the tradition from the music world. The events which have changed her life have transformed our view of her. As a woman who appeared to threaten the integrity of the Beatles, and to bring to Lennon an avant-garde influence incomprehensible to his public, she once seemed alien to us. But since his death we see her differently. With eyes slightly raised, and hands tentatively suppliant, she now appeals to us all – in Linda McCartney's picture (60). Portrait photography has always rested upon this sense of type. It accumulates our experience of history and humanity, and makes it whole.

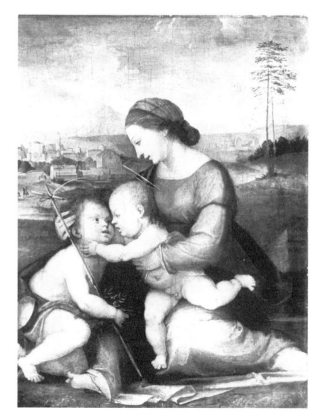

Fig. 15 FRA BARTOLOMMEO, *Holy Family*, early 16C (National Gallery, London)

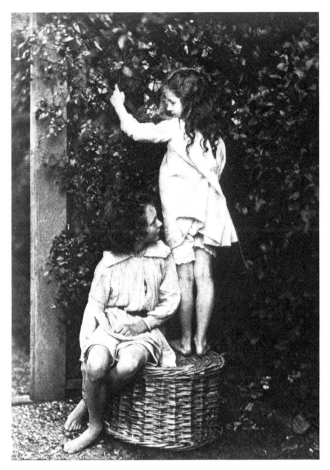

54 EVELEEN TENNANT MYERS, *The Summer Garden*, *c.* 1889

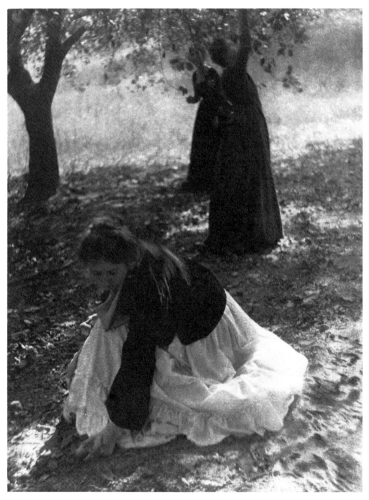

55 CLARENCE H. WHITE, *The Orchard*, 1902

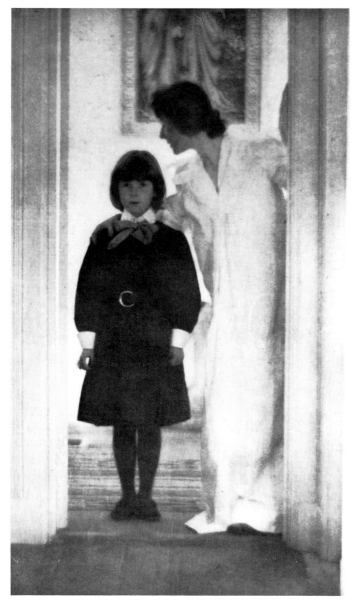

56 GERTRUDE KÄSEBIER, *Blessed Art Thou Among Women*, 1899

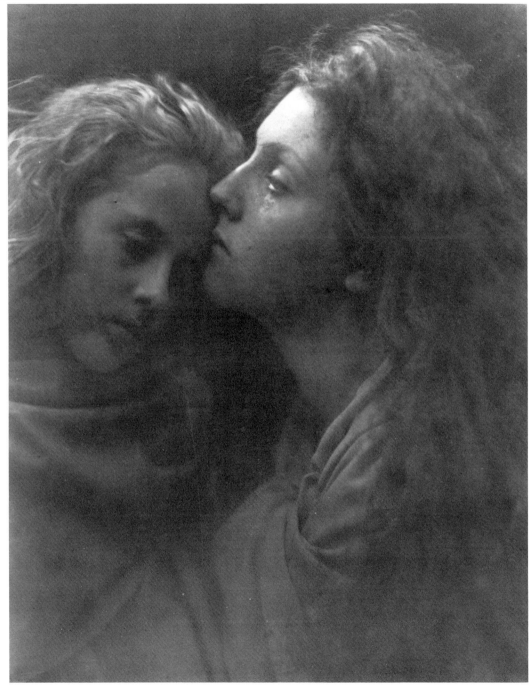

57 JULIA MARGARET CAMERON, *The Kiss of Peace*, 1869

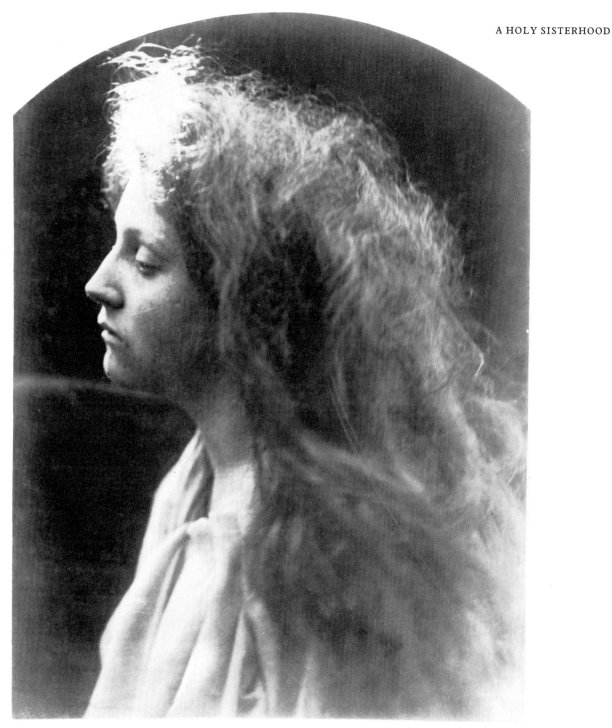

58 Julia Margaret Cameron, *The Angel at the Tomb*, 1869

60 LINDA MCCARTNEY, *Yoko Ono, London*, 1968

14. FRUIT PIECES

Who of the Law's sour juice sweet wine did make,
Even God himself, being pressèd for my sake.

(George Herbert)[53]

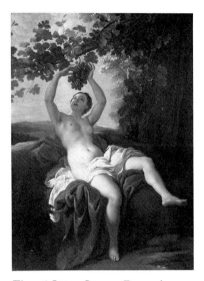

Fig. 16 JEAN-SIMON BERTHÉLEMY, *Erigone*, 18C (Stirling and Francine Clark Art Institute, Williamstown, Mass.)

THE RISE OF PHOTOGRAPHY coincided with the first art-historical scholarship and with the spirit of revivalism which accompanied it. The iconographic work undertaken by Britons, French, and Germans in the eighteen-forties was the basis for Roger Fenton's reproductive photography at the British Museum, and C. Thurston Thompson's at what became the Victoria and Albert Museum. Fenton's bacchic cup (61) comes from a series of still-life photographs in which, in the tradition of Dutch *pronk* painting, *objets d'art* and other ostentatiously rich objects were employed to express a risen middle-class. Fenton's objects appear to be nineteenth-century copies. It is possible that he was friendly with the fruit-painter William Henry Hunt, whose pictures of grapes, and of a bacchic cup he may have known.[54] At least one of his still-lifes in this series included the niche-format of early Dutch paintings representing the bunch of grapes as a Eucharistic symbol. But Fenton's range is between images of possible Christian significance and playful paganism. Several pictures feature two figurines, one with a Red Cross Knight's shield (St Michael), another carrying ears of corn (Ceres). Fenton's bacchic cup, emptied and knocked over, together with the partly-eaten, partly-spoiling melon, might constitute a vanity symbol were it not for the witty placement of the upturned buttocks next to two peaches.

Alfred Stieglitz's studies of his wife, Georgia O'Keeffe, are probably much more firmly based in European pictorial tradition than has been recognized. His study of hands and grapes (62) suggests a painting by the French painter, Jean-Simon Berthélemy (1743–1811), based on the legend of Erigone (fig. 16). Drawn from a single line in Ovid the story goes that Erigone, daughter of Icarius who received the gift of the vine from Dionysus, was seduced by Bacchus disguised as a bunch of grapes. Stieglitz's image expresses the sexual tension of the moment of seduction. He appears to refer us to such a painting by including part of a picture-frame.

Caponigro's vine (63) prospers against all the odds of age and drought to bring forth a goodly store of grapes. It has the feeling not of an *objet d'art* but of its opposite, an *objet trouvé*. It is not so much typical in its beauty as vital, an affirmation of life.

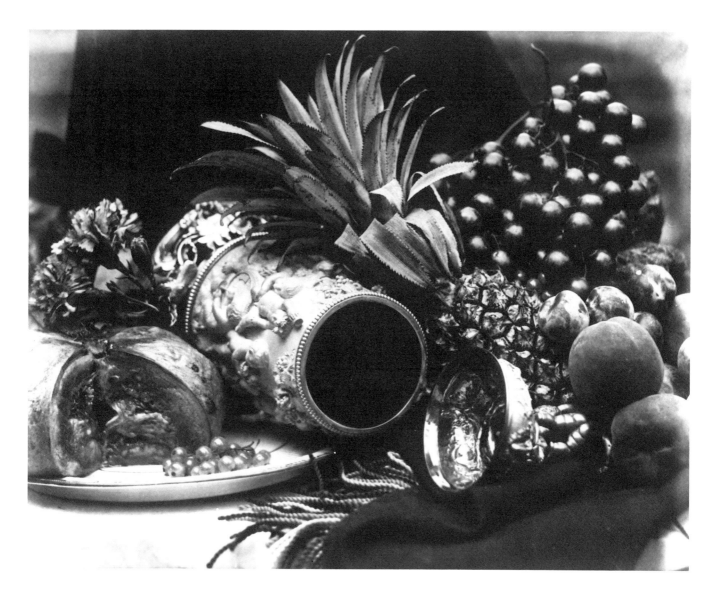

61 ROGER FENTON, *Ivory Cup and Fruit*, c. 1860

FRUIT PIECES

62 ALFRED STIEGLITZ, *Georgia O'Keeffe : A Portrait – Hands and Grapes*, 1921

63 PAUL CAPONIGRO, *Tecate, New Mexico*, 1979

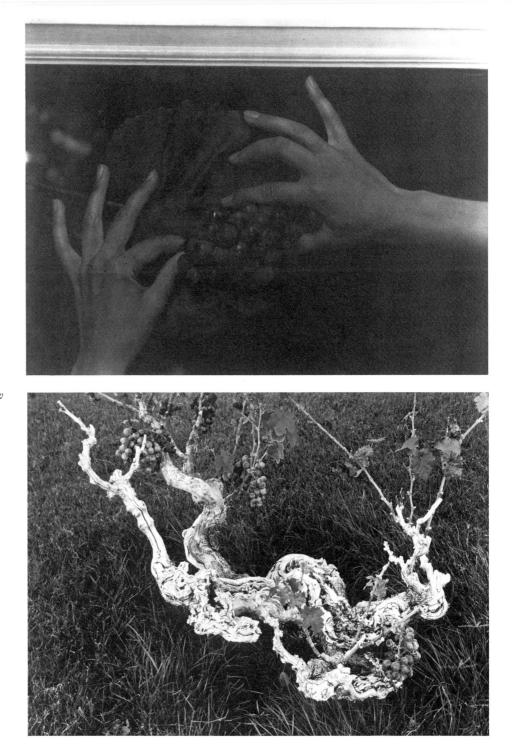

15. PICTORIAL PRODUCTIONS

Now try to conceive the image of an actual person, in
whom, somehow, all those impressions of the vine and its
fruit, as the highest type of the life of the green sap, had
become incorporate; – so conceive an image into which
the beauty 'born' of the vine, has passed; and you have
the idea of Dionysus. (Walter Pater)[55]

HERMAE ARE PILLARS surmounted by the bearded or youthful
head of the god Hermes, father of Pan. In Clarence White's pic-
ture (64) his face expresses the degree of trickery and cunning
which we associate with Shakespeare's Puck. The grapes around
the pillar are coaxed and tended by the boy who makes the connection
between Bacchus and Hermes. He is the soul of the Herm of Pan. The statue
which White used in his picture belonged to Fred Holland Day who also
used it himself. Day used the correct locations – caves and pine-trees – and
the attributes – tortoises, honey, shepherds' crooks – of Hermes Pan. Hermes
was the god of gymnasia, of the lyre, and of sleep and dreams, but in the
seventeenth century and earlier, like other pagan gods, he was moralized
in the typological manner as a foreshadowing of Christ. Writers and artists
of the Decadence at the end of the nineteenth century managed to be pagan
and Catholic at the same time. The attitude of aesthetes like Walter Pater,
the founder of the Aesthetic movement, was that the pagan gods were treated
as diabolical because later Christian doctrine refused to acknowledge their
divinity. They were not destroyed but lived on in disguise in the form of
evil spirits in remote places. John Addington Symonds also took up the study
of the Greek gods at a time of renewed interest in the Renaissance after
Ruskin's Pre-Raphaelite efforts to promote the mediaeval period had waned.
Symonds recommended the series of nude photographs of boys and young
men in the guise of the gods by Plüschow of Naples and the Baron von
Gloeden in Capri and in Sicily, but he might have added those by Frederick
William Rolfe, who called himself Baron Corvo. This is the basis of a tradi-
tion to which George Platt Lynes, Minor White, and Robert Mapplethorpe
belong, but whereas they favoured a sharp-focused realism in their pictorial
productions, Clarence White and Day preferred suggestion to statement,
and a misty and dim sorrow to satyric sensuality. Day's dark nude (65)
belongs to the gods of Grecian sleep and dreams rather than to Map-

plethorpe's gods of the New York gymnasia. Yet both types are derived from the same Hermes myth.

Religious elements were combined with the occult throughout the period. The English Catholic poets, Francis Thompson and Lionel Johnson, were published in Boston by Day, who also followed the work of the Society for Psychical Research led by F. W. H. Myers, who was Eveleen Myers' husband (54). Day's nude combines the neo-pagan with the Christian in terms which express a melancholy Dionysus or a languorous St Sebastian. The specific attributes of thyrsus and arrows have vanished but the ideal type remains as the dark figure leans back with one arm uplifted in sleep or sacrifice. As Pater wrote in his *Study of Dionysus*,

> . . . the beautiful, weeping creature vexed by the wind, suffering, torn to pieces, and rejuvenescent again at last, like a tender shoot of living green out of the hardness and stony darkness of the earth, becomes an emblem or ideal of chastening and purification, and of final victory through suffering.[56]

The Orphic aspect of Dionysus, the tearing apart of the divine poet, appealed strongly to the erotic and masochistic imagination of Day, who advanced the type to include sacrifice by crucifixion in his famous *Seven Last Words of Christ*.

Coburn's picture of a Pan figure at the top of some steps (66) incorporates interest in the Greek mystery religion with commitment to the Christian ladder of perfection as well as to the pantheistic clearing or glade in the background. At the bottom of the steps is a shadow, where the unseen aspirant stands ready to make the ascent, step-by-step, to enlightenment. The clearing represents his instant approach to enlightenment by sudden illumination. Coburn was a quietist interested in the Orphic tradition as a method of religious consecration, and in the hermetic tradition, not of Hermes Pan but of Hermes Trismegistus, the mediaeval alchemist.

Annie Brigman's picture (67) expresses perfectly the neo-paganism of the later Pictorialist period in photography. Pater quoted the Homeric hymn to Aphrodite, which celebrates the dryads in the pine-trees: 'When at last the appointed hour of their death has come, first of all, those fair trees are dried up; the bark perishes from around them, and the branches fall away; and therewith the soul of them deserts the light of the sun.'[57] Brigman's picture is a tautology: a torso emerges from another torso, *torso* being the Italian word for a tree-stump. Brigman was an allegorist, yet there is a relation between her work and that of Edward Weston after 1920 in that she,

too, related her figures to the landscape in a metamorphic way. But whereas she remained all her life a Symbolist, Weston became a vitalist. His *Driftwood Stump* (68) contains not so much the soul but the biological principle of the spiral in the tree. Although blasted and dead it remains inherently vital because of the flaming pattern of its organic growth. To describe such growth, whether in a tree-stump or in the nude, was to discover in the objective world an unseen reality, which confirmed both Darwinians and typologists in their belief that the world was, in essence, sufficiently designed to be considered divine. Whether the tree-stump was the product of the conscious design of God or the unconscious evolution of perfect growth its tragic decay was mitigated by the powerful twist of its body even in death. Brigman showed a resemblance between the aspiring figure and the jagged stump but Weston implied an unspoken relation between them while only showing one of them.

Minor White's picture (69) makes an interesting comparison with Mapplethorpe's (70). Like Brigman's picture, it includes dead wood, but the correspondence is now at the level of limbs rather than whole trunks. In Mapplethorpe, however, the element of wood is not a found object but a carefully constructed one. *Phillip on a Pedestal* is a Herm of Pan: the base of the pedestal forms four triangles; the fifth consists of the shaft running to and from Phillip's body in another plane. In other images by Mapplethorpe an actual phallus may form the plinth. The pentangle, consisting of five triangles, is Mapplethorpe's preferred geometric shape. The pentagram is his logo. In the nineteenth-century occult revival led by Eliphas Lévi, whose followers included Aleister Crowley, it crowned the devil's forehead. The world of Day, Symonds, and Beardsley, was one in which homosexuality was repressed by law. Its old gods lived in disguise as evil spirits because they were forced underground. They merged with the demonic perhaps less to subvert the world than to gain an imaginative space which they could call their own. Certainly, the drooping head in Mapplethorpe's picture, and the darkened head of Minor White's are not aggressive but withdrawn. This is the sorrowful aspect of the myth of Hermes and Dionysus. As Minor White wrote,

> To Death I leave
> My breath
> to die[58]

64 Clarence H. White, *The Herm of Pan*, 1905

65 Fred Holland Day, *Nude in Shadow*, 1910

66 ALVIN LANGDON COBURN, *The Enchanted Garden*, c. 1905

67 ANNIE W. BRIGMAN, *Soul of the Blasted Pine*, 1907

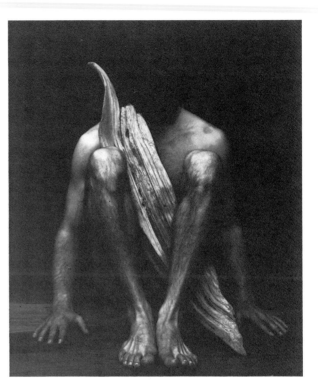

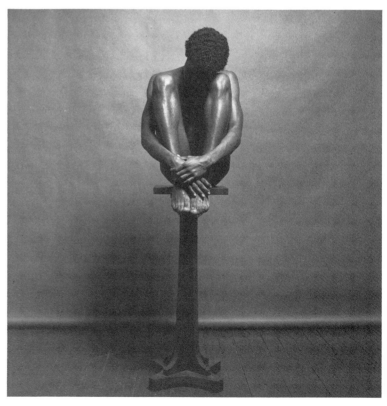

69 MINOR WHITE,
*Nude and Driftwood,
San Francisco*, 1947

68 EDWARD WESTON,
Driftwood Stump, 1937

70 ROBERT MAPPLETHORPE,
Phillip on Pedestal, 1979

16. ACCOMPANYING IDEAS

We may here observe a strange Proneness in our Minds
to make perpetual Comparisons of all things which occur
to our Observation, even those which would seem very
remote . . . Inanimate Objects have often such positions as
resemble those of the human body in various
Circumstances. (Francis Hutcheson)[59]

WHEN MINOR WHITE talked to Weston about his famous photographs of peppers and shells Weston admitted the presence of a certain extra quality – 'a plus' – in them but resented the suggestion that it was sex: 'I made them for their beauty, something else crept in.'[60] Weston was powerless to prevent the proneness of the mind to find resemblances in objects. In the privacy of his *Daybooks* he admitted such a propensity was natural. Edward Steichen, however, actively sought such resemblances: 'I began to reason that, if it was possible to photograph objects in a way that makes them suggest something entirely different, perhaps it would be possible to give abstract meanings to very literal photographs.'[61] But then he went on to say that the abstraction based on symbols was only practicable if the symbols themselves were universal rather than personal. So he went to nature to find forms which would be universally acceptable as significant. His wheelbarrow and flower pots (71) was a natural enough subject for a breeder of delphiniums, but to others they suggested something like a Bofors gun. In fact this was neither a picturesque nor a surrealistic image but one which related to Steichen's interest in the spiral. From the time that he discovered Theodore Andrea Cook's *The Curves of Life* (1914) he had begun to believe that 'the shape of the universe itself was the logarithmic spiral.' The need for artists, like all occult philosophers, to discover in nature a discipline to under-pin their work is deep-seated. Leonardo and Goethe preceded Steichen and Weston in an interest in spiral formations.

Weston's nautilus is dealt with at great length in Cook's chapter on flat spirals in shells. When Weston photographed it in section it looked like a scientific illustration from Cook's book, but when he presented it end on and upside down (72), he was both making it available for comparison with other objects and repressing the comparison at the same time. The right way up, in its swimming position, it evokes comparison with the vulva, but upside down this is partly revoked. Now it suggests death as a kind of

memento mori in the Dutch tradition: '*Skull* and *shell* were originally the same word, or very nearly so' (Talbot).

Steichen's sunflower (73) is part of a series which began by way of illustration of Cook's evidence on the spiral pattern of seeds on the face of the sunflower, but here it is both an expressionist mirror of the soul in the manner of Van Gogh, and a seventeenth-century emblem: as soon as the sunflower begins to dry out its leaves begin to curl, suggesting that as our natural heat diminishes so, too, do our human bodies weaken. The ambiguity of the curled shape is surely present in Weston's nude in the sand dunes (74). Like all spiralists, Weston is interested here in torque of ribs as well as more general curves of life. But the curve of sleep also presages death as hands and feet dig into the sand. Of all the series of sand-dune nudes, usually erotic displays of adolescent limbs, this one is a flat-spiral counterpart to the vertical-spiral driftwood torso (68). Both of them assert a kind of life-in-death, death-in-life – a transitional state.

Frederick Evans' undercroft in Gloucester Cathedral (75) is the intellectual link between the nineteenth and the twentieth centuries. Evans provided illustrations for Cook's book *The Curves of Life*, and Cook wrote the text for Evans' *Twenty-five Great Houses of France*. It is very likely that the Steichen-Weston interest in spirals originated with Cook-Evans. As a Swedenborgian Evans belonged to a tradition which connected occult and non-occult science in a remarkable synthesis. He knew that the cathedral was essentially a thesaurus, a treasure-house of memory: its corners, arches, and intercolumnar spaces were *loci* in which were housed specific memories. The cathedral comprised a series of memory-places by which the Christian idea of the world could be represented. The author of *Ad Herennium*, the classical source of all memory-systems, actually described the necessary lighting conditions for the 'images' mentally placed in such *loci* – not too brightly lit so as to avoid dazzle, but not so dark as to lose detail in the shadows.[62] But if Evans was as conversant as Coburn with the Masonic conception of the building as a memory-system he was more concerned than any of his Pictorialist contemporaries with biological and mathematical analogues between art and nature. His photomicrographs, his pendulum drawings, his probable knowledge of Cook's first book, *The Spiral in Art and Nature* (1903), inform all his greatest photographs.[63] Like Weston, he manipulates the image, in this case Norman arches, by photographing it obliquely to make of the rounded arches a great coil or spiral, ending in a curving stairway leading to the light. This crypt is a great sea-shell lying on the ocean-bed of an almost immemorial time, which Evans at least could still call to mind.

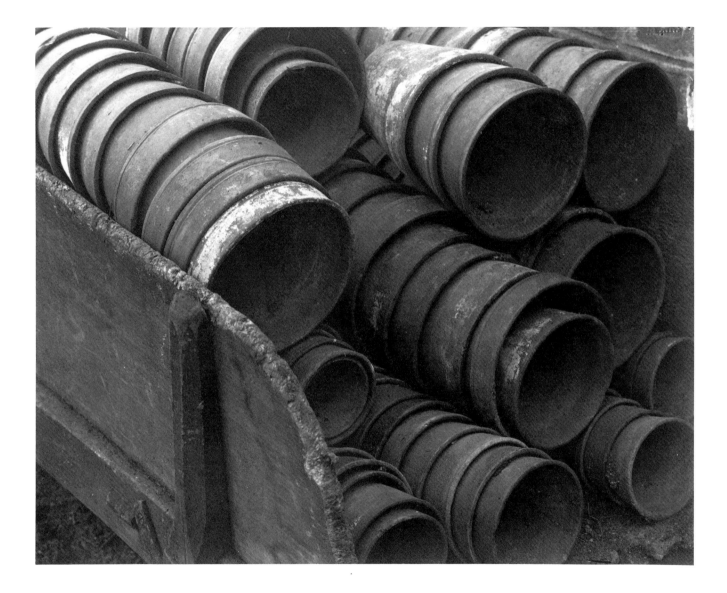

71 EDWARD STEICHEN, *Wheelbarrow with Flower Pots*, 1920

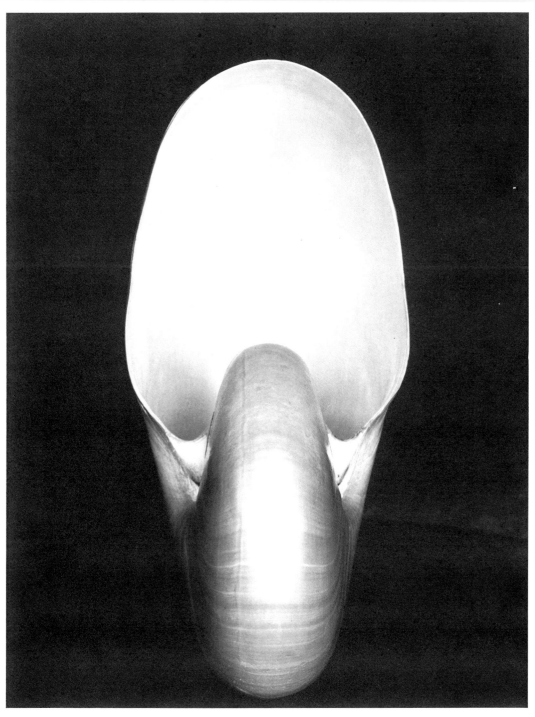

72 EDWARD WESTON, *Shell*, 1927

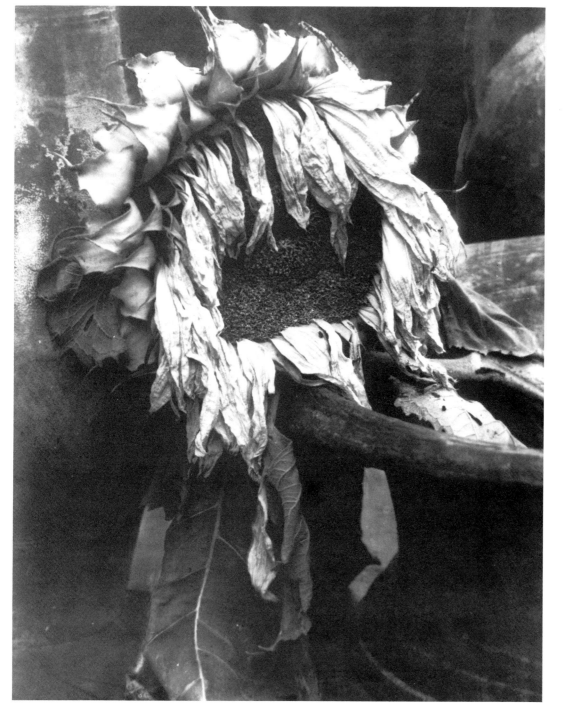

73 EDWARD STEICHEN, *Sunflower*, 1920

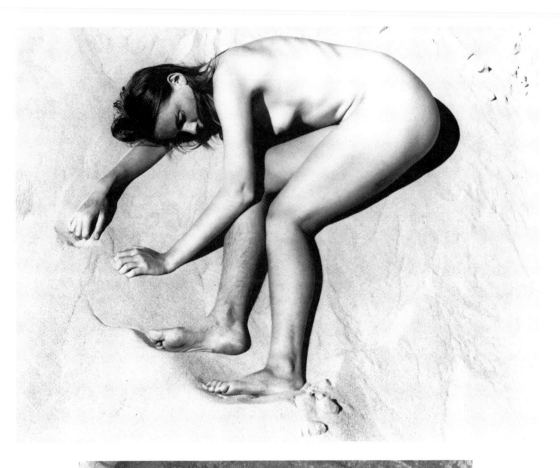

74 EDWARD WESTON,
Nude, 1936

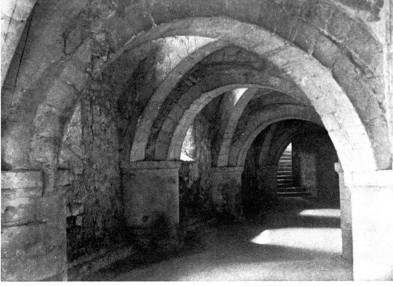

75 FREDERICK H. EVANS,
Undercroft, Gloucester Cathedral,
c. 1903

17. FAMILIAR AND DAILY OCCURRENCES

> Art always aims at the representation of Reality, i.e. of
> Truth; and no departure from truth is permissible, except
> such as inevitably lies in the nature of the medium itself.
> Realism is thus the basis of all art, and its antithesis is not
> Idealism, but Falsism. (G. H. Lewes)[64]

NOTHING COULD BE more straightforward than a set of rungs set in two uprights used for ascending a building or a haystack. It would seem, to some, that Talbot photographed ladders because they were simply there. Photography showed what it could do by drawing a ladder and its shadows in an unerring manner. Alternatively, photography could not help recording certain irrelevant incidentals of daily life – like ladders. Two of his most famous images contain them, *The Haystack* and *The Ladder* (76 – frontis.), and there are many more in his work. At one level no doubt he did see ladders in terms of measuring space. A *scale* of measurement is essentially a *ladder*:

> Many other terms in use among geometers at first denoted very common and familiar objects, resembling in form, to a certain extent at least, the bodies which geometry treats of. *Dice* were the first Cubes . . . The first *Cylinder* was a *Garden-roller*, which must be acknowledged to be a very fair resemblance . . . The later geometers of Greece followed up the same idea of naming geometrical conceptions from fancied resemblances to natural objects . . . Thus, the *Cissoid* of Diocles from its creeping up against its asymptote, like *ivy*, up a wall. (Talbot)

The creeper in Talbot's picture is not ivy but its climbing method contrasts strongly with that of the ladder. The naturalistic aspects of Talbot's image are so strong (rolled-up coat, top-hats, cobbles) that we forget how the Northern tradition in art concealed emblems within such everyday objects. The ladder in Dürer's *Sojourn of the Holy Family in Egypt* (fig. 3) leans against the cross-shaped beam above at the same angle as in Depositions from the Cross. To put Talbot's ladder picture next to Dürer's *The Mass of St Gregory* (fig. 17) may strike some as profane, indeed blasphemous, but

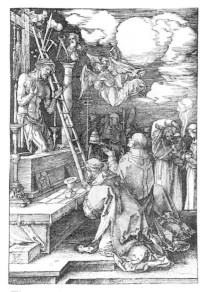

Fig. 17 ALBRECHT DÜRER, *The Mass of St Gregory*, 1511

the type-form of two men with one above is too close to reject out of hand, especially when we read Talbot on the word *sublime*: 'The leading idea seems to be, anything which we LOOK UP TO, which implies the notion of its being very high;'[65] and on *Gregorius*: 'means *watchful*, *vigilant*: an excellent name for a Saint or other Holy man.'

Martin Parr's man on his steps cleaning his window performs a homely enough chore (77). George Eliot, G. H. Lewes's companion in realism, wrote: '. . . let us always have men ready to give the loving pains of a life to the faithful representation of commonplace things – men who see beauty in these commonplace things, and delight in showing how kindly the light of heaven falls on them.'[66] But those who have seen Bennie Sims's shoeshine picture (50) and the light above that scene, and have thought about Coburn's *Enchanted Garden* (66) and his set of steps, will feel something is happening in Parr's picture, which goes beyond the act of window-cleaning. Edwin Smith's picture (78), taken in an English parish church, shows just how strong the ladder tradition remains. Unlike Frederick Evans who carefully removed most furniture and as many furnishings as possible from his interiors, Smith delighted in such domestic and commonplace subjects: the benches, one plain, one with an ornate back; the staircase and the little ladder; the chair; the candle-holders; the weights of a hidden clock; the roses, the cloth hanging from a candle-bracket, and the little crucifix, make this little corner into a chapel blessed by the silvery light of Smith's print. If Frederick Evans and Coburn were Platonists who believed that objects in the world represented the higher reality which our souls knew before their descent below, Talbot and Smith were, perhaps, Aristotelians, who believed that knowledge came from sensory impressions, actual objects, worked upon by the imagination. In this Smith is the English counterpart of the American Walker Evans, whose hanging towel sanctifies the interior of the Alabaman shack (83) in exactly the same way that Smith's purifies a Gloucestershire church. In the end, the two kinds of truth, Platonist and Aristotelian, are not antithetical but complementary – capable of union in one mind.

Dürer's great wood-cut (fig. 3) is a veritable primer of types, a visual etymology of pictorial language. Joseph wields a tool, an adze, to make a coffin for the child that lies in the cradle. Mary spins the wool to make the shroud already on her lap. Near a great closed door with immense hinges, a ladder leans against a cross-beam support. Next to a rough shed, a stable with a wicket gate, stands a pile of unplaned lumber from which will be made the crosses of the thieves of Calvary. The curved staircase, a spiral over a crypt, is the way Mary went to be presented in the Temple. Water

flows from the well of Baptism, and immediately behind it is the wicker fence and tree of the Flight into Egypt; to the right of that, the covered lychgate through which they came to arrest Him in the garden. But let us rest our attention on the open gate which has no door.

Keith's doorway on Iona is almost completely closed (79); one effect of the shadow is to block an interior view. This is, perhaps, no more than an artist's conventional way of adding variety by breaking the regularity of the frontal approach, in the decorative manner of John Cotman. But the feeling of the darkness strikes deeper. This is a potential abyss: 'I think it probable that *gulf* in the sense of "abyss", is related to . . . the verb to *gulp* down, or swallow' (Talbot). Faced with the Norman Romanesque the imagination plunges into loss of self, a kind of drowning.

Coburn's bridge (80) is quite different in feeling. Faced with such a gulf, man can still so meditate upon a relation between objects as to retain his hope. The bridge pier, which is static, abuts upon a boat potentially moving but for a moment at least held steady over the immolating flood. The anchor of Hope is on its deck to reassure the emblematic mind. But it is the imaginative but actual space created by the overarching bridge, a shape neither Gothic, Romanesque, nor Classical, but proto-Oriental, which convinces us that the veil can yet be penetrated.

Roger Fenton's views of the exteriors of our great cathedrals are mostly topographic. Like Cotman before him, he was willing to fulfil the demands of Gothic Revivalist taste. His half-open doorways with figures can be extremely evocative, but his occasional cathedral interiors, though hardly approaching the consistently fine work of Frederick Evans (75), are also very impressive. Fenton's picture (81), divided into two parts by the central pillar, has on one side the back-projected illumination of a stained-glass window with figures, and on the other side clear glass through which a blinding flood of light pours in. It was made in the wake of the Oxford movement to reform the ritual of the Anglican church; Newman favoured the visual presentation of the sacraments; others preferred the literary authority of Paul's blinding conversion on the road to Damascus. In Fenton's picture the door to salvation is now objectified as a window. Through which way should he enter in – the Catholic or the Protestant way?

The idea of stepping, over a threshold, through a door, up a ladder, is fundamental to Talbot's progressive thought. *The Ladder* (76 – frontis.) has two doors, the large one open below, the smaller one above: there are two levels at which one can enter in; one easy, one more difficult. Talbot's *The Open Door* (82) is more obviously an emblematic picture. The clearest indi-

cation comes from the broom. This is the means by which the threshold
and the house have been swept clean and the means by which those who
enter can shake the dust from off their feet. It is in Pieter de Hooch's famous
picture of a courtyard in Delft (fig. 18). Hooch's painting is divided, like
Fenton's photograph (81). On one side is a woman with a child, who has
committed herself to the clutter of secular life. On the other, beneath a Dutch
inscription indicating the blessings of retirement from the world, stands a
young woman looking inward. The broom is carefully placed; other versions

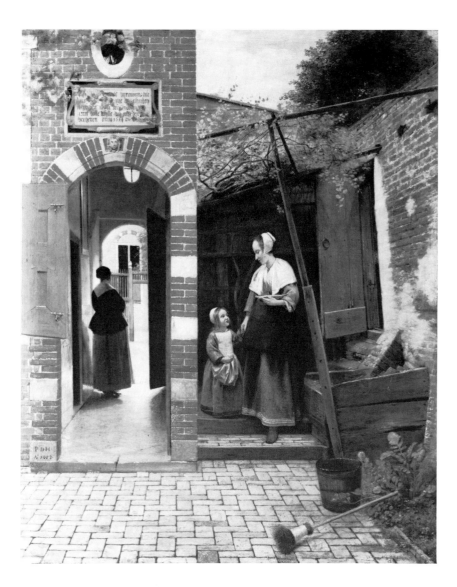

Fig. 18 PIETER DE HOOCH, *A Court-
yard in Delft*, 1658 (National Gallery,
London)

of Talbot's picture indeed show how he experimented with the placement of his brush.

On the door-jamb hangs the same bridle of the emblem books:

Lord, let thy sacred *Law* at all times, be
A *Rule*, a *Master*, and a *Glass* to me;
(A *Bridle* and a *Light*) that I may, still,
Both know my *Duty*, and obey thy *Will* . . .[67]

Talbot's light is a lantern ready to be lit. Like Bennie Sims's light-bulb (50) it is not, of course, needed at midday except for emblematic purposes. It reminds us of our need for inner illumination, for divine grace and reason. The lattice-window within the darkness is a second door which we do not penetrate so quickly. Finally, the vine is a symbol of the Church.

Walker Evans, like Talbot, owes much to the Dutch (83). The lamp on the table has been just as carefully placed as Talbot's lantern. The jar on the dresser catches the light from an unseen window but, front and back, the lighting of the scene is unobtrusive. Unlike the British photographers, Evans avoided *chiaroscuro*; ostensibly on the grounds that it was painterly rather than photographic, but actually because he was a Magic Realist in the illusionistic American tradition of Harnett, Haberle and Peto.[68] His regard for the real did not lead him to documentary naturalism so much as to an ideal apprehension of the spirit of things. The stone-ware jar is an object of contemplation, like an empty basket or a copper pan in Chardin. The door-jamb divides the picture between the dining-area within, and the washing-area without. The two-dimensionality of the washing-area is what makes the picture at this point so Magic Realist. The pleasure of it is that depth is so much removed that for a moment the photographed objects strike us as real things. The closeness of the basin to the boards, and the way the folds of the cloth hug the jamb so neatly denies us any binocular parallax between the objects photographed and the photograph itself. The Magic Realist effect is so transparent that it makes this place less a sharecropper's shack than a Shaker dwelling. From observing light fall upon a few objects Evans has moved to a radiant point in the mind, a transcendental sense of spirit. He prepares himself at the door, and goes through: '*Door*, Germ. *Thur*, or *Thor*. Closely related to this word is the German preposition *durch*, Engl. *through, thoro*' (as *thoroughfare*, from *durchfahren*)' (Talbot). To go through a door is to undertake a journey – into Egypt, at home in Lacock, and also into Alabama.

77 MARTIN PARR, *Hangingroyd Road, Hebden Bridge*, 1974

78 EDWIN SMITH, *Didmarton Parish Church, Gloucestershire*, 1961

79 THOMAS KEITH, *St Oran's Chapel, Iona*, 1856

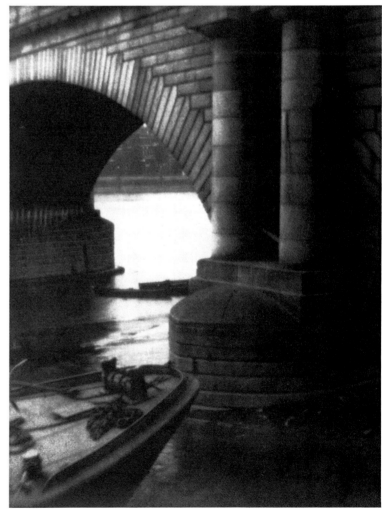

80 ALVIN LANGDON COBURN, *Waterloo Bridge, c.* 1903

81 ROGER FENTON, *Wells Cathedral,*
c. 1857

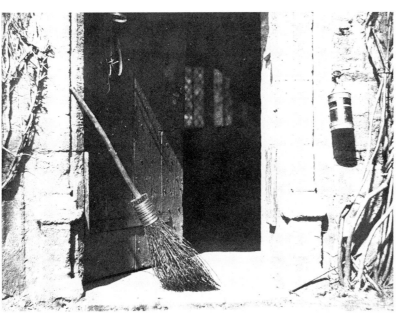

82 W. H. F. TALBOT, *The Open Door,* 1843

115

83 WALKER EVANS, *Hale County,
Alabama*, 1936

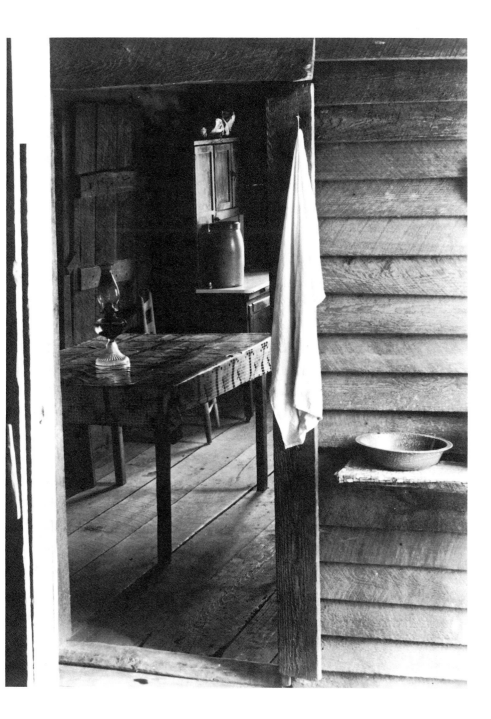

18. OUR NOBILITY

But bless us, things may be lovable that are not altogether handsome, I hope? I am not at all sure that the majority of the human race have not been ugly, and even among those 'lords of their kind', the British, squat figures, ill-shapen nostrils, and dingy complexions are not startling exceptions. Yet there is a great deal of family love amongst us. (George Eliot)[69]

THE LONG TRADITION of family groups called conversation pieces is regarded as a particularly British contribution to the history of art in the eighteenth century and later. Usually the members of the group are engaged in conversation or some kind of activity. In Patrick Lichfield's photograph of the Duke and Duchess of Windsor they are having their picture taken (84). Lichfield described how he had to sacrifice his own dignity by falling off a chair in order to get a response from them. He had to amuse them even as Steichen had to irritate J. P. Morgan to get what he wanted. But what Lichfield got is no less damaging a critique of the King Who Abdicated. The Duke appears to wink, to crack an uneven smile; the Duchess offers a masked and pursed smirk. The image shows exactly where the power of the relationship lay as well as something of the irrepressible ordinariness of the ex-king and the capacity for suffering of the most famous divorced woman in history. Her lower lip protrudes slightly just as the angle of his chin makes it recede literally and metaphorically. Different from the romantic photographs taken by Beaton at the time of their wedding, Lichfield's candid exposé of their natures and of their relations makes him a Royal Photographer with an edge. Talbot suggested that *grimace* may come form the Spanish *grimio*, a monkey. In another place he claimed he had finally found the true etym of grimace:

It comes from the old Saxon term *grima*, a mask . . . The ancient comic masks were so distorted that any ludicrous or distorted expression of the countenance (or *grimace*) was naturally compared to them. Shakespeare says that persons who are in bodily pain 'make faces like mummers'. Now mummers wore masks. This shows how naturally a *grimace* is connected with the notion of a *mask*.

The Duke is a jester, the Duchess wears a mask. They are mummers both.

To be born first in line for a throne is to be born less with a silver spoon in the mouth than with a trauma in the psyche.

Like Diane Arbus's freaks, true aristocrats graduate at birth. Her senior citizens (85) have had to wait more than sixty years to become true freaks. The leopard-skin dress and the ermine cape finally belong to the same wardrobe, and the handbag comes into its own as an orb, but at the final moment of coronation the Queen is blinded by flash. But Arbus's aristocrats wear meaningless masks under a parodic eye which leaves them expressionless. Yet, who are we to say that a deal of family love does not exist between these ex-regal and un-regal couples? Human feeling does not wait for orthodox ideas of beauty, as we can see in the picture by Graham Smith (86). Smith's family exists in defiance of our preconceived ideas:

> *Existence* considered alone, and without specifying any particular mode of existence, is a very abstract idea. Our rude and simple ancestors must have had some trouble in giving it a name. How did they overcome this difficulty?
>
> If we examine, we shall perceive that they called in the assistance of the verb *stare, to stand*, a good positive verb, capable of giving its solid support to the somewhat too impalpable *esse, to be*. (Talbot)

The mode of existence of Bernard McGhee is specified in terms of a family love which is palpably uneasy and touchingly solid, but literally *stands*. Brandt's Sikh family in a church, however, takes us back in time: it *sits* (87). As a place in the Christian memory-system a crypt evokes the tomb in which Christ was laid. But, unusually, the child is in the father's lap and not the mother's. The normal distance between Mary and Joseph in Holy Family pictures is maintained, but the charge of the Child has changed hands because the father's relation to the son in Sikh culture is different from that in Christian culture. The sleeping child imitates death, the mother mourns, and the father is absorbed. The picture is a cultural composite, deflecting the Christian typology in a new direction, making the Sikhs Christian, and inaugurating in the inauspicious dark of war-time London a new strain of our nobility. It is continued in Ian Berry's picture taken in an East Midlands hospital (88) where the angelic attendants wear white raiments but have black heads and hands. The interaction of thought and feeling transforms the picture from an image of something strange into the recognition that at our death contact between eyes transcends colour, and that an ultimate positive-negative reversal is finally achieved.

84 PATRICK LICHFIELD, *Duke and Duchess of Windsor*, 1967

85 DIANE ARBUS, *King and Queen*, 1970

86 GRAHAM SMITH,
*Bernard McGhee and Jan
with Son*, 1984

87 BILL BRANDT,
Christ Church Crypt, Spitalfields,
5 November 1940

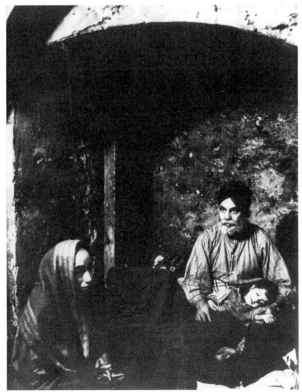

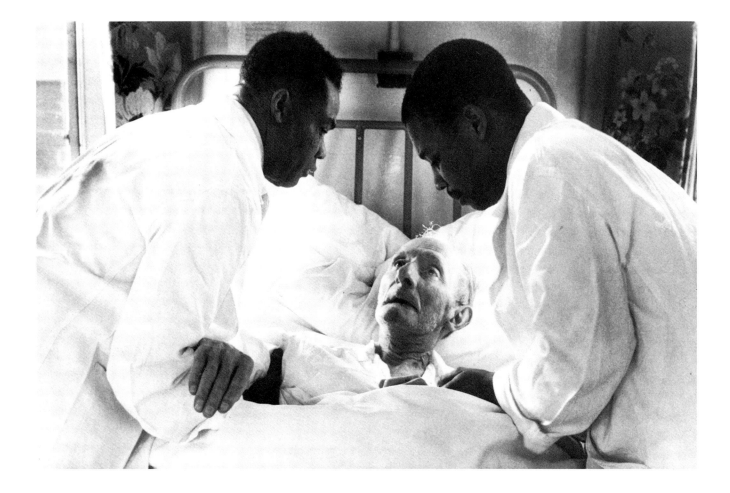

88 IAN BERRY, *East Midlands, c.* 1976

19. THE GENERAL EFFECT

Generalisation, whatever Platonists, or Plato himself at
mistaken moments, may have to say about it, is a method,
not of obliterating the concrete phenomenon, but of
enriching it, with the joint perspective, the significance,
the expressiveness, of all things besides. (Walter Pater)[70]

STRAND'S YOUTH is up against the wall, defiant (89). Boards behind
him as vertical as the highlight on his nose, he stands up to us,
hair flaming: the straight nose is the stem of a chalice sculpted from
his frontal bone to read CUP-BEARER, TORCH-BEARER (whether
résistant or *collabo* take your choice). Cameron's young woman is just as fierce
(90). She may have jasmine in her hair but her eyes, her hand on hip, express
experience more than innocence. Cameron called her Pomona, 'goddess of
Fruit; or as we may venture to translate it, the goddess with the apple, since
she is represented with a large Apple in her hand on many ancient monu-
ments' (Talbot).[71] In Cameron's picture she is Milton's Eve in *Paradise Lost*:

> She as a veil down to her slender waist
> Her unadorned tresses wore
> Dishevelled . . . (IV: 304–6)

Talbot is good on *tresses*: 'A *tress*, in Italian *treccia*; whence the adjective
intrecciato, twisted, tangled, *intricate*'; which he then relates to 'An *intrigue*,
Italian *intrigo*, means a tangled plot, something difficult to unravel or dis-
cover.' Cameron's young woman is intricate indeed; subjugated and resent-
ful at the same time. She is the Alice Liddell of Lewis Carroll's exploitation
photographs, but now her eyes are like pruning-shears, and her cocked hip
like any courtesan's.

Nine out of ten people who look at Steichen's portrait of J. P. Morgan
see an angry man with a dagger in his hand (91). The tenth sees that the
man 'really' grasps the arm of a chair. 'It is not only photographers who
read meanings into their photographs,' cried Steichen triumphantly. But
read Steichen's account of his relationship with Morgan before you decide
who is right about the dagger.[72] Steichen had time to set up the janitor of
the building in Morgan's chair, so he knew what he was getting in advance.
He went out of his way to annoy Morgan to get that irritated expression

Fig. 19 RICHARD HOUSTON after Rembrandt, *The Executioner*, 1759 (Bodleian Library, Oxford)

in combination with the hand gripping the chair. Morgan tore up the print when he saw what Steichen had done – all this by Steichen's own admission. What Steichen had made, in fact, was a version of a picture by Rembrandt sometimes called *The Executioner* (fig. 19), which he intended to represent St Bartholomew with the attribute of his martyrdom, a knife.[73] Consciously or not, Steichen knew Morgan's type, and it was not that of the saint. Morgan and the rest of us were right. Emerson's gamekeeper is also an executioner of sorts (92). Generically, he can be found in the earliest British photographs, in the work of Talbot and P. H. Delamotte. He lords it over a domain. The winter sun glints on his boots, shines his corduroys, polishes his elbow and the butt of his gun. A gamekeeper is a polished poacher – a policeman. (Talbot suggested that *polite* was a word which took its meaning from both *polish* and *police*). Hands cupped against the wind, the counterbalance of the gun-butt makes it an extension of his body. Smoke brings sleep to the dark, polished dogs, and death to the light-coloured game. The wind in the reeds plays Aeolus to this figure's Prometheus. Carlyle by Cameron is no less lethal (93). Anna Jameson, Cameron's great contemporary, wrote of him:

> He is a man who carries his bright intellect as a light in a dark-lantern; he sees only the objects on which he chooses to throw that blaze of light: those he sees vividly, but, as it were, exclusively. All other things, though lying near, are dark, because perversely he *will* not throw the light of his mind upon them.[74]

His type is St Jerome who contemplates a skull which is perhaps his own; or Diogenes with his lantern; or Heraclitus, who retreated from the world in disgust.

P. G. Hamerton, the finest British critic of the graphic arts, and W. M. Rossetti considered that Cameron's work had a quality of breadth of effect which left her rivals cold. Behind her rejection of Pre-Raphaelite high finish lay an aesthetic influenced via G. F. Watts by the Venetian painters. In terms of finish the British have always been distrustful of high gloss. Talbot cited Bacon to make an unconscious comment, perhaps, on the daguerreotype and the paper negative: 'Bacon calls bits of polished steel, steel *glosses*. *Gloss* seems nearly related to *glass*', but he had no doubt that *gloss* implied a super-ficial lustre, a false glow. But broad effect included interpretation of character according to a typological system. As Tennyson said of his own approach to King Arthur: 'I intended him to represent the Ideal in the Soul of Man

coming into contact with the warring elements of the flesh.'[75] The concrete phenomenon, as Pater called it, is not to be obliterated but something more than likeness is necessary in the portrait. This is Talbot's etymology of *portrait*:

> When a likeness is drawn extremely resembling it is said in French to be *trait pour trait* (line for line). But this does not seem likely to have been the origin of the word *portrait* . . . Let us try a bold conjecture! Perhaps the first syllable is the word *Port* . . . *Portrait* would then mean 'delineation of the port' – drawing or painting of the air, mien, demeanour, carriage.

Portraiture is not a matter of likeness but of striking resemblance to an ideal type. The cabinet-size Victorian photographic print hardly ever achieved it, of course.

In D. W. Griffith's masterpiece *The Birth of a Nation* (1915), President Lincoln just before he is shot gathers a shawl about his shoulders partly in intimation of his death, partly of his rôle as mother of the nation. An expression of sorrowful compassion hardly ever leaves his face in Griffith's film. Alexander Gardner's image (94) is of the same kind. The plate broken, the image slightly out of focus, the picture is nevertheless wholly perfect. It is the quality of broad typological effect, 'of all things besides,' which makes it so good.

Eugene Smith's picture of Schweitzer (95) was made in Colorado five years before he went to Africa to photograph him for *Life* magazine. What is he doing? Caressing a child, tending an animal, playing the organ? All and none of these things. In Africa Smith had difficulties with Schweitzer's demeanour before the camera. He confronted him: 'He put his hand on his forehead and closed his eyes and said, "I want you to remain in Lambaréné. You can photograph whatever you wish." '[76] The gesture recurs throughout the *Life* assignment in the angle of Schweitzer's head tilted forward, over the patients, over the desk, over the organ. He is the great Overseer. Head dropped, eyes downcast and veiled by glasses, hair and moustache as impenetrable as a crown of thorns, this is the man of mercy, victim of the media.

89 PAUL STRAND, *Young Boy, Gondeville, Charente, France*, 1951

90 JULIA MARGARET CAMERON, *Pomona*, 1872

91 EDWARD STEICHEN, *J. P. Morgan*, 1903

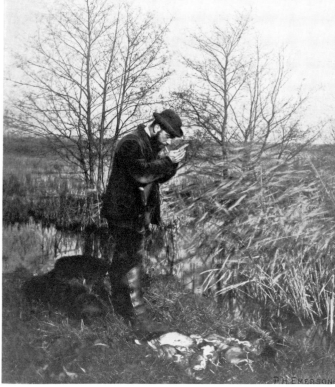

92 P. H. EMERSON, *At the Covert Corner, c.* 1886

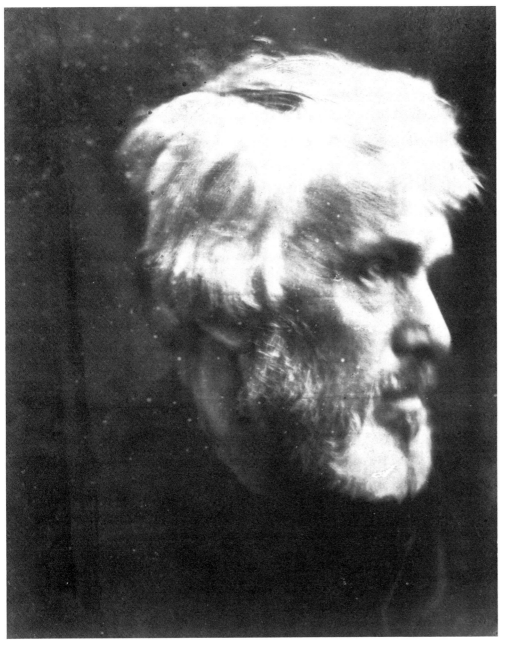

93 JULIA MARGARET CAMERON, *Thomas Carlyle*, 1867

94 ALEXANDER GARDNER, *Abraham Lincoln*, 1865

95 W. EUGENE SMITH, *Albert Schweitzer, Aspen, Colorado*, 1949

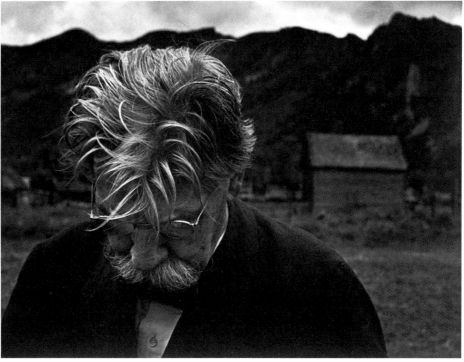

20. SOLEMN IMAGININGS

The first requisite, then, in an Epitaph is, that it should
speak, in a tone which shall sink into the heart, the general
language of humanity as connected with the subject of
death – the source from which an epitaph proceeds – of
death, and of life. (Wordsworth)[77]

IN HIS BOOK *A Day Off*, Tony Ray-Jones offered several images based
on couples, but in his abbey picture he gave us a multiplicity of them
(96). The humour of it: three pairs of public-school boys (forever
gay in the public imagination) set off by a grammar-school couple
engaged in love-play (his tie, her legs). The ironic context: monastic ruins
and roses, manicured lawns, all courtesy of the Department of the Environ-
ment. The solemn reflection: the ultimate couple is the pair of tombstones.
But there is a touch of the self-portrait, too, in the boy with his back to
us photographing his friend: Ray-Jones as the self-conscious public-school
boy that he used to be himself. The churchyard picture by Hill and Adamson
(97) belongs to the elegiac tradition, which in its British form was made
famous by Thomas Gray's *Elegy Written in a Country Churchyard*. The tone
is melancholic and yet heroic. But Greyfriars is hardly a rustic churchyard.
To the Scots it is the place where the National Covenant was signed in 1638
by which English interference with the Reformed Kirk was rejected, and
a monument was raised in 1706, replaced in 1771, to the Covenanters of
the Restoration period. So Hill's picture is a kind of elegy, Calvinist rather
than Arcadian, for all Scotsmen. Gray shared his knowledge of the Ossianic,
bardic poems, and also believed that every nation has its own artistic char-
acter. In Hill's picture a tree appears to grow from out of the monument,
and barely visible in this print but clearly so in another by Hill (fig. 20),
and one later by Thomas Keith, is a small stone skull. This is the traditional
depiction of the serpent's head and the tree of life which became the tree
of fallen knowledge (fig. 21). The men's hats on the ground may be also
related to the same idea. Usually the hat is held in the hand as a badge of
rank, but on occasion it seems just too far away not to offer itself for con-
sideration as an empty shell or skull. This is Talbot on the word *casque*:

A helmet; from the French. Properly means a skull-cap, from Spanish *casco*,
the skull ... also signifies any shell, hull, or tegument. It may be observed
that *skull* and *shell* were originally the same word, or very nearly so.

Fig. 20 HILL AND ADAMSON,
Naismith Monument, Greyfriars,
c. 1845 (Scottish National Portrait
Gallery)

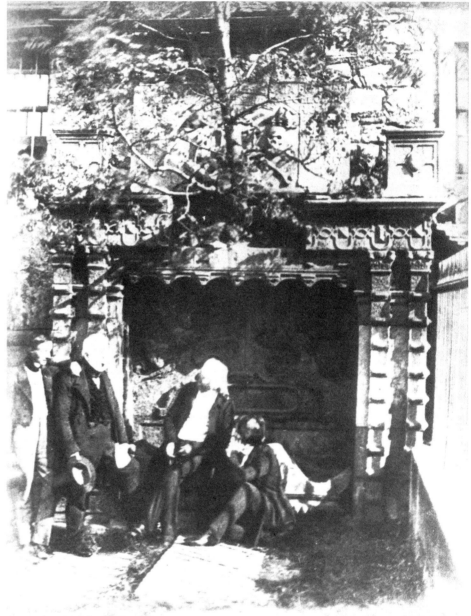

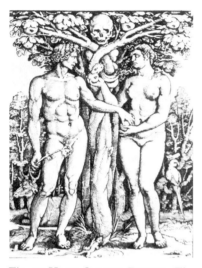

Fig. 21 HANS SEBALD BEHAM, *The
Fall, c.* 1535

Hill used helmets with small boys, and bonnets for ladies, to suggest a
mysterious connection between the two. Certainly this seems to be the case
with the picture of David Roberts, the popular Scottish painter of Egyptian
monuments, where not only his hat suggest a *memento mori* but also the head-

shaped ornament and niche which forms a kind of sarcophagus (fig. 22).

Strand reflected on his Wall Street picture (98) in both representational and abstract terms. In one interview he spoke of the windows as Behemothic, perhaps thinking of Fritz Lang's *Metropolis* (1927): 'a great maw into which the people rush.' In another he emphasized static abstraction, 'sinister windows – blind shapes.'[78] This is the Morgan Guaranty Trust Building overlooked by a statue of George Washington from the Treasury building. It is Strand's portrait of J. P. Morgan and a *memento mori* of the modern, urban kind at the same time. In the version of the image in the film he made with Charles Sheeler, *Manhatta* (1920), the effect is less elegiac because the reflections of the people in the windows are a lively part of the kaleidoscopic city scene. But even in *Manhatta* Trinity Church graveyard scenes are juxtaposed with the busy urban scene under the influence of Edgar Lee Masters' book of epitaphs, *A Spoon River Anthology* (1915).

Walker Evans' tin building is a façade (99). It is his most characteristic composition – the two-dimensional grid, the anti-perspectival view. (Talbot: 'the science of Perspective is not correctly named; it ought to be Prospective, being the art of delineating a prospect or view.') As a metaphor for paucity of resources, architectural and human, the façade is unbeatable. What is Richard Perkins' epitaph to be? A closed door, some torn posters, and a pile of sand. Bright and shiny, lovingly rendered in sharp detail, his monument is melancholy all the same. Calvert Jones' picture (100) is of the same kind, but made on the oblique. The pile of rubble refers to all the houses and none in particular. It is as English in its precise generality as Evans' picture is American in its pointed thought. The pictures of graves which Evans made in Hale County, Alabama demand a response, but Jones does not centre his heap so much as include it casually. These piles of dirt speak volumes. They answer the need we feel for the expression of something within us all, and epitomize the language of typical actuality which is photography's endless strength:

> Yet ev'n these bones from insult to protect
> Some frail memorial still erected nigh,
> With uncouth rhymes and shapeless sculpture decked,
> Implores the passing tribute of a sigh.

Fig. 22 HILL AND ADAMSON, *David Roberts, Greyfriars*, c. 1845 (Scottish National Portrait Gallery)

96 TONY RAY-JONES, *Yorkshire*, 1967

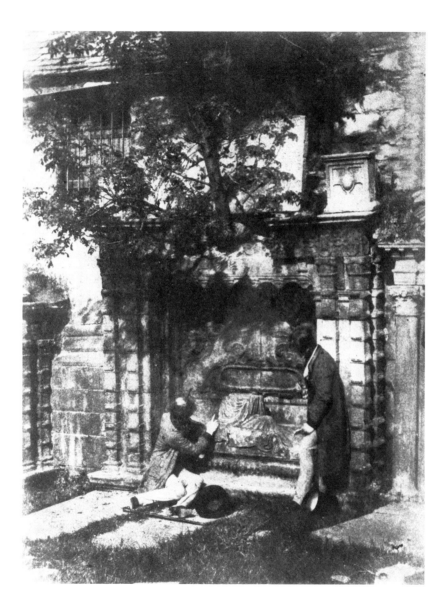

97 D. O. HILL and ROBERT ADAMSON, *Greyfriars Churchyard, the Naismith Monument, c.* 1845

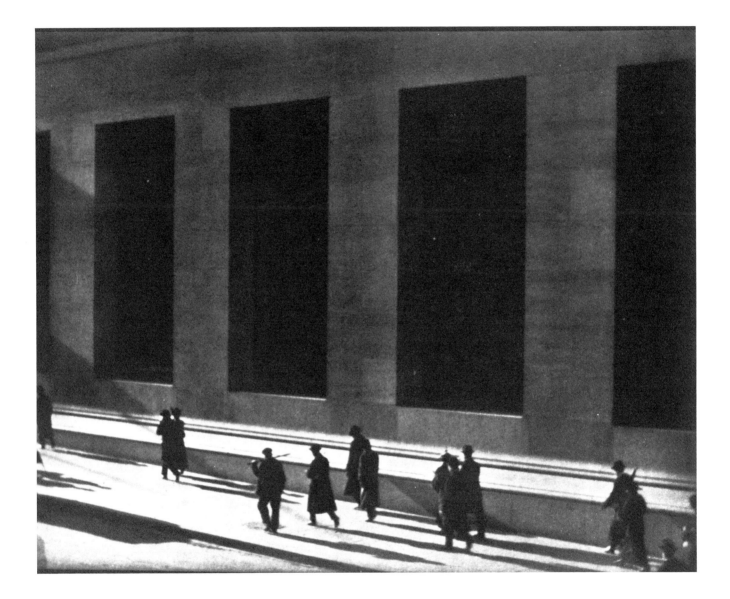

98 PAUL STRAND, *Wall Street, New York*, 1915

99 WALKER EVANS, *Moundville, Alabama*, 1936

100 RICHARD CALVERT JONES, *Street Scene, c.* 1845

137

NOTES

1. W. H. F. Talbot, *English Etymologies,* London 1847. The quotations which follow are, perhaps, too numerous to cite on each occasion. The reader is referred to copies of this 495-page work in the Bodleian and British Libraries.
2. Talbot, 'Some Account of the Art of Photogenic Drawing' (1839), in *Photography in Print* ed. V. Goldberg, New York 1981, 41.
3. For an account of the Stirling-Maxwell Collection, Glasgow University Library, see *A Choice of Emblemes,* catalogue of an exhibition, 1985.
4. Christopher Lloyd, 'Picture Hunting in Italy: Some Unpublished Letters (1824–1829)', *Italian Studies* XXX (1975), 47.
5. See a fine essay by Brian Vickers, 'Analogy versus Identity', in *Occult and Scientific Mentalities in the Renaissance,* ed. B. Vickers, Cambridge 1984.
6. See Frances Yates, *The Art of Memory,* London 1966.
7. See the frontispiece to *Seventeenth-Century Imagery,* ed. E. Miner, London 1971; and G. Buckland, *Fox Talbot and the Invention of Photography,* London 1980, 87.
8. Talbot, *Hermes – or Classical and Antiquarian Researches,* two parts, London 1838, I: 47.
9. Talbot, *Pencil of Nature,* London 1844–46, not paginated: facing plate XVII.
10. William M. Ivins, *How Prints Look,* Boston 1958, 146.
11. *North British Review* 36 (February 1862), 189.
12. Talbot, *Pencil of Nature,* facing plate IV.
13. See Frederick C. Moffatt, *Arthur Wesley Dow (1857–1922),* Washington, DC 1978.
14. *Ruskin's Letters from Venice 1851–1852,* ed. J. L. Bradley, New Haven, Conn. 1955, 297.
15. William M. Ivins, *Notes on Prints,* New York 1967, 39, 71.
16. John Ruskin, *Modern Painters,* London 1904, 6 vols., I: 343.
17. Ruskin, V: 103.
18. See the sharecropper sequence in which the undergrowth acts as a trap, and vegetation conceals the anti-union men.
19. *Whitney's 'Choice of Emblems',* ed. H. Green, London 1866, 55; 'bell' is an old word for bubble.
20. Ruskin, II: 109.
21. Richard Payne Knight, *An Analytical Enquiry into the Principles of Taste,* 4th edn, 1808, 152.
22. Theodore Roethke, *Collected Poems,* London 1985, from *Sequence, Sometimes Metaphysical,* 231.
23. Francis Hutcheson, *An Inquiry into the Original of Our Ideas of Beauty and Virtue,* London 1725, 76.
24. *Photography in Print,* 41.
25. Jonathan Richardson, *Two Discourses,* London 1719, 201.
26. Wright Morris, *Photographs & Words,* ed. J. Alinder, Friends of Photography, Carmel, Ca. 1982, 18–19.
27. *Photography in Print,* 153.
28. Ruskin, IV: 17.
29. See *American Light: the Luminist Movement,* ed. J. Wilmerding, Washington, DC 1980.
30. William Hogarth, *The Analysis of Beauty,* London 1753, 38–39, 52.
31. Minor White, *Mirrors Manifestations Messages,* Millerton, NY 1969, 146.
32. Knight, 97–8.
33. A. Symons, *London: A Book of Aspects,* London 1909, 2.
34. H. James, *English Hours,* London 1905, 16.
35. P. H. Emerson, *Naturalistic Photography,* 3rd edn, London 1899, Bk III: 39.
36. Ruskin, IV: 6.
37. Bill Brandt, *Literary Britain,* ed. M. Haworth-Booth, London 1984, n.p.
38. Ruskin, V: 325.
39. P. H. Emerson, *Souvenir of the Foxwold Billiard Circle,* Southbourne-on-Sea 1908, 15.
40. Ruskin, IV: 66–7.
41. The broken tree as type of Christ's sacrifice in Italian painting may descend etymologically through the Picturesque to Walker Evans's tree-stump, and to a man's back.
42. Talbot, *Hermes,* I: 15.

43. Knight, 194–5.

44. For a good, recent account of Associationism see Christopher Titterington, 'William Turner of Oxford', *Old Water-Colour Society's Club Annual* LIX (1984), 23–51.

45. W. Evans, 'Photography', in *Quality: Its Image in the Arts*, ed. L. Kronenberger, New York 1969, 170.

46. See J. Szarkowski, *Walker Evans*, New York 1971, 122, for a version cropped to eliminate Bennie's signature and allow Evans to sign it himself.

47. R. W. Emerson, *Collected Works*, Cambridge, Mass. 1971, I: 12.

48. J. A. Symonds, 'Mrs. F. W. H. Myers', *Sun Artists* 7 (April 1891), 54.

49. See Mike Weaver, *William Carlos Williams: The American Background*, Cambridge 1971, 55–64.

50. James Hinton, 'English Art', *An English Madonna*, London 1884, 23.

51. Andrew Marvell, 'Upon Appleton House', stanza 41.

52. Cecil Beaton, *Self-Portrait with Friends*, ed. R. Buckle, London 1982, 304.

53. George Herbert, 'The Bunch of Grapes'.

54. John Witt, *William Henry Hunt (1790–1864)*, London 1982, plate 101, exhibited Old Water-Colour Society, 1851. Hunt's grape pictures commanded high prices in the eighteen-fifties.

55. W. Pater, *Works*, London 1901, 8 vols, VII: 37–8.

56. Pater, VII: 49.

57. Pater, VII: 12.

58. Minor White, 75.

59. Hutcheson, 37–8.

60. Minor White, 76.

61. Edward Steichen, *A Life in Photography*, London 1963, Ch. 5, n.p.

62. Yates, 8.

63. See Anne Kelsey Hammond, 'Frederick Evans: The Interior Vision', *Creative Camera* 243 (March 1985), 12–26.

64. G. H. Lewes, 'Realism and Idealism', *Westminster Review* XIX (October 1858), 493.

65. Talbot, *Hermes*, I: 34.

66. George Eliot, *Adam Bede*, Ch. 17.

67. George Wither, *A Collection of Emblemes*, Columbia, South Carolina 1975, 169.

68. See Alfred Frankenstein, *After the Hunt: W. Harnett and Other American Still-life Painters*, Berkeley, Ca. 1953.

69. George Eliot, *Ibid.*

70. W. Pater, *Plato and Platonism*, London 1893, 159.

71. Talbot, *The Antiquity of the Book of Genesis*, London 1839, 55–6.

72. Steichen, Ch. 3, n.p.

73. *Art Pictorial and Industrial* II (July 1871), facing 72. For a different engraving after Rembrandt by Charles Phillips entitled 'The Assassin', see S. Slive, 'Realism and Symbolism in Seventeenth-Century Dutch Painting', *Daedalus* XCI (1962), 484–7.

74. A. Jameson, *A Commonplace Book of Thoughts, Memories, and Fancies*, London 1854, 316–17.

75. *Tennyson and his Friends*, ed. Hallam, Lord Tennyson, London 1911, 498.

76. P. Hill and T. J. Cooper, *Dialogue with Photography*, New York 1979, 269.

77. *Wordsworth's Literary Criticism*, ed. W. J. B. Owen, London 1974, 'Essays upon Epitaphs', 128–9.

78. Paul Strand, *Sixty Years of Photographs*, Millerton, N.Y. 1976, 144, 19.

INDEX OF ARTISTS